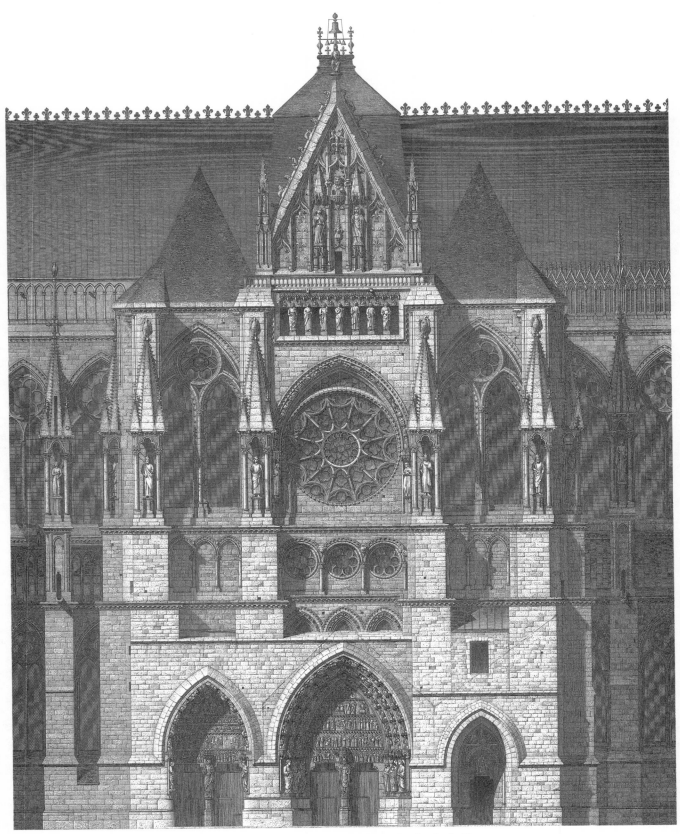

Elevation, North Transept, Reims Cathedral, France

MEDIEVAL ORNAMENT AND DESIGN

Jules Gailhabaud

DOVER PUBLICATIONS, INC.
Mineola, New York

Bibliographical Note

This Dover edition, first published in 2006, is an original selection of plates from *L'Architecture du V^{me} au XV^{me} Siècle et Les Arts Qui en Dependent,* published by Gide, Editeur, Paris, 1858.

DOVER *Pictorial Archive* SERIES

Library of Congress Cataloging-in-Publication Data

Gailhabaud, Jules, 1810–1888.
 [Architecture du Vme au XVIIme siècle et les arts qui en dépendent. Selections]
 Medieval ornament and design / Jules Gailhabaud.
 p. cm.
 Selection of plates from: L'architecture du Vme au XVIIme siècle et les arts qui en dépendent. Paris : Gide, 1858.
 ISBN 0-486-44885-1 (pbk.)
 1. Decoration and ornament, Medieval—Pictorial works. 2. Decoration and ornament, Architectural—Europe—Pictorial works. 3. Architecture, Medieval—Pictorial works. I. Title.

NA3390.G35 2006
729.09'02—dc22

 2006045430

Manufactured in the United States of America
Dover Publications, Inc., 31 East 2nd Street, Mineola, N.Y. 11501

PUBLISHER'S NOTE

This volume contains an eye-opening panorama of the rich decorative art of the Middle Ages, spanning over 1,000 years of history. Included are hundreds of carefully selected authentic engravings of stonework, statuary, bronze and ironwork, woodcarving, and much more, mainly from Western European churches, cathedrals, chapels, and abbeys, but also from mosques of the Middle East. Ranging from fifth-century bas-reliefs on the tomb of SS. Simeon and Jude in Verona, to the soaring Gothic fretwork of Notre Dame Cathedral in Paris, to seventeenth-century window grilles of a house in Troyes, this art exemplifies the devotion, skill, and master craftsmanship of medieval architects, artists and artisans. More than 300 detailed illustrations, culled from a rare nineteenth-century French portfolio, depict architectural ornament, door and ceiling decorations, candelabras, stalls, enclosures, altars, lecterns, pulpits, baptismal fonts, funeral chapels, tombstones, and many other artifacts and relics of Western churches and cathedrals. In addition to a wealth of ecclesiastical art and decorative elements, this royalty-free resource also includes humble, often-overlooked design details that adorned butcher shops, hospitals, private homes, and other non-ecclesiastical venues. Meticulously reproduced here to retain the authenticity and flavor of the originals, these masterly engravings represent a treasury of ready-to-use art, as well as an ongoing source of arts and crafts inspiration.

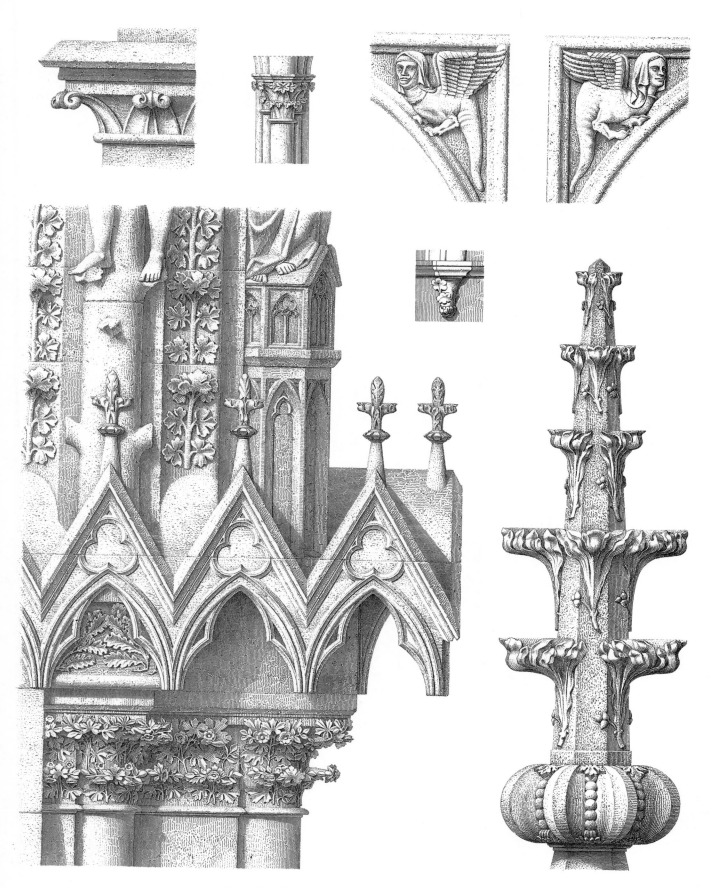

1. Details of Facade, Reims Cathedral, France

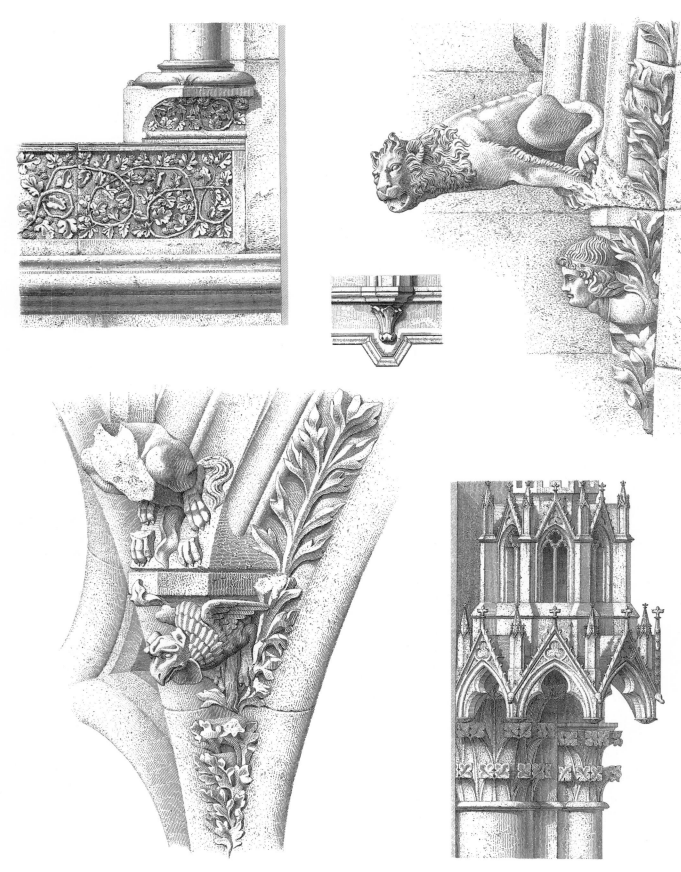

2. Details of Facade, Transept, Reims Cathedral, France

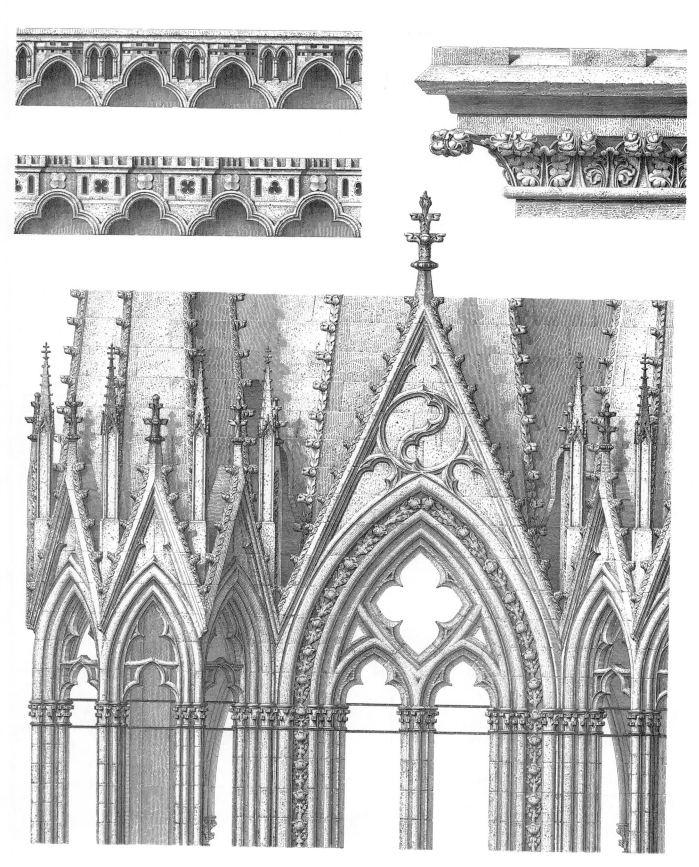

3. Details of Bell Tower, Transept, Reims Cathedral, France

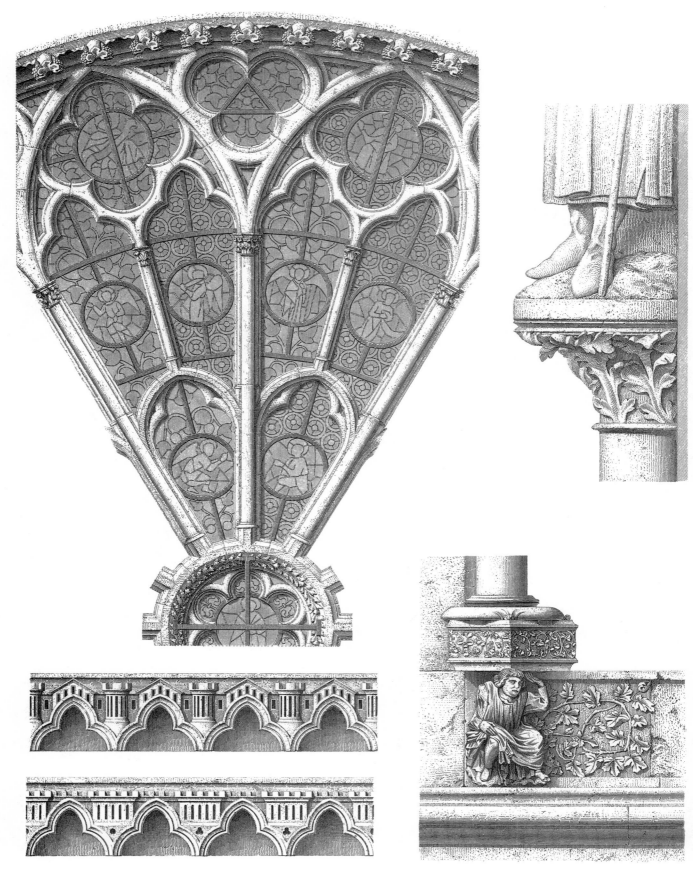

4. Details of Facade, Transept, Reims Cathedral, France

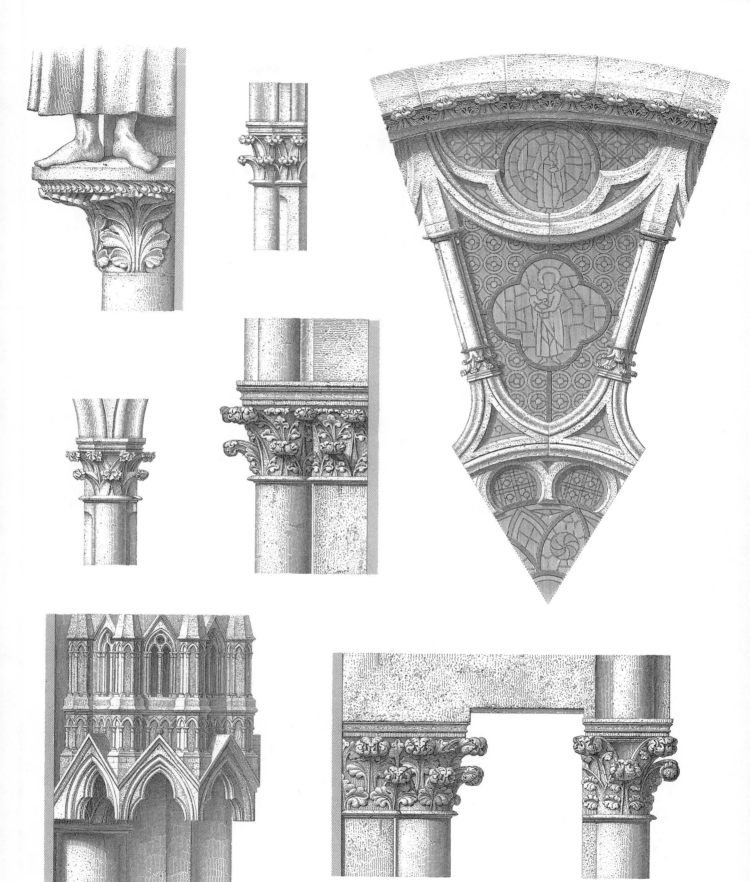

5. Details of Transept, Reims Cathedral, France

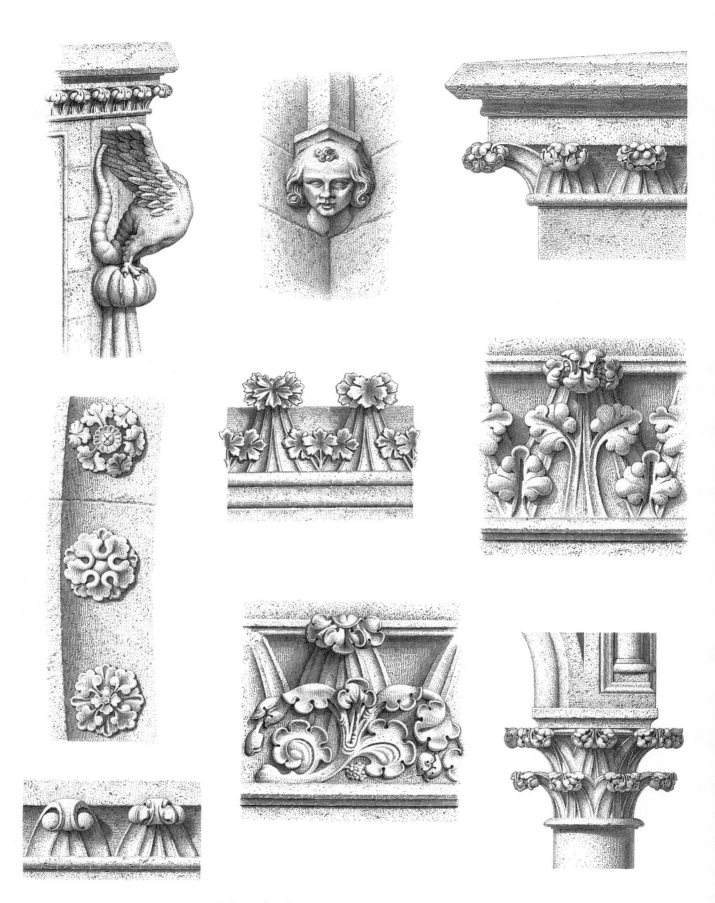

6. Details of Transept, Reims Cathedral, France

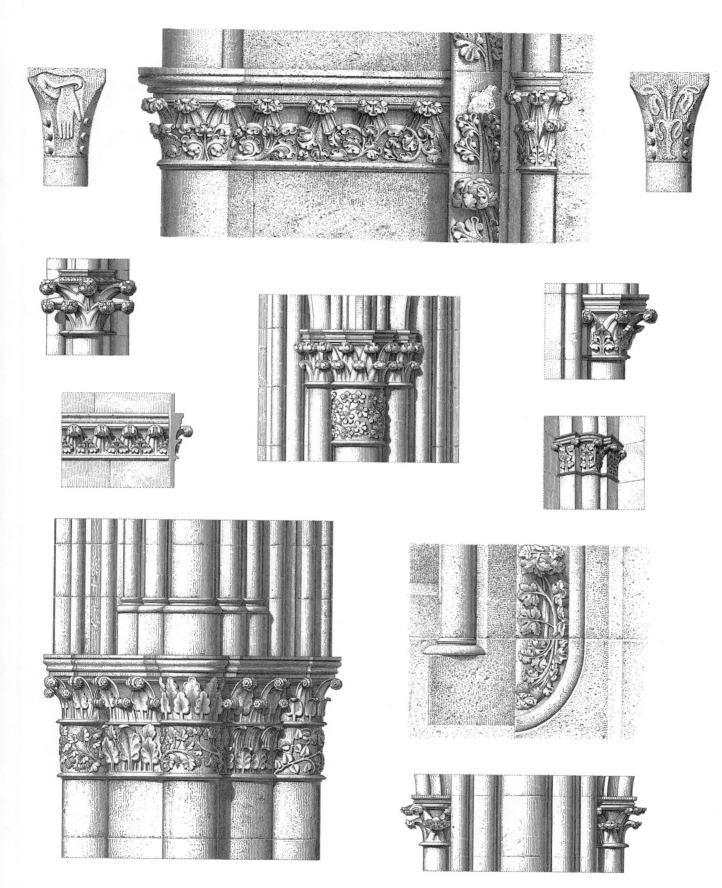

7. Details of an Interior Bay, Reims Cathedral, France; Details of the Church of Saint Généroux,
France; Details of the Chapel of the Archbishop, Reims Cathedral, France

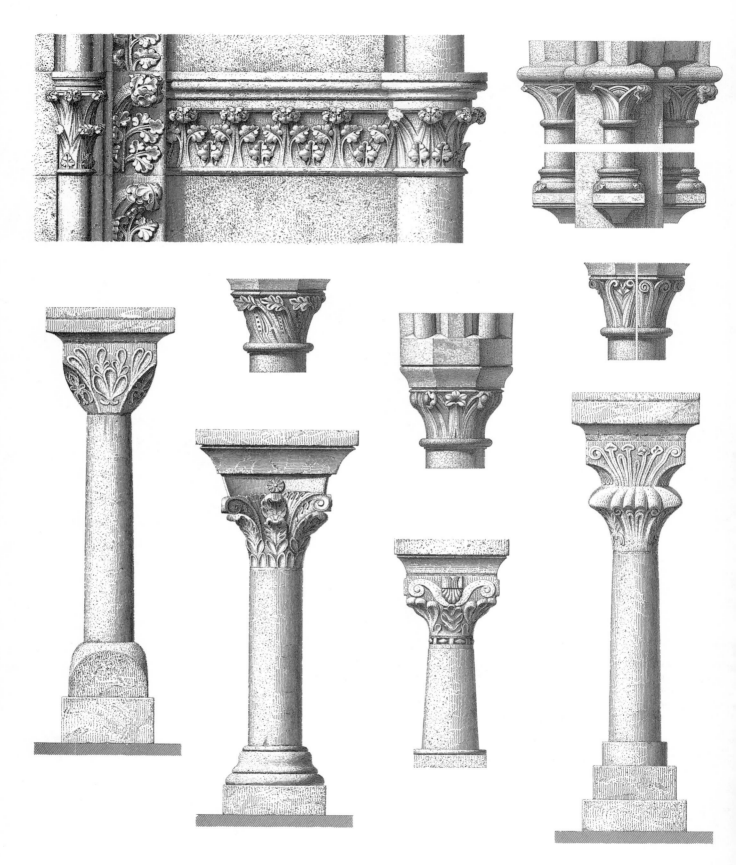

8. Details of the Knight Commander's Chapel at Ramersdorf, near Bonn; Details,
Church of Saint Généroux, France

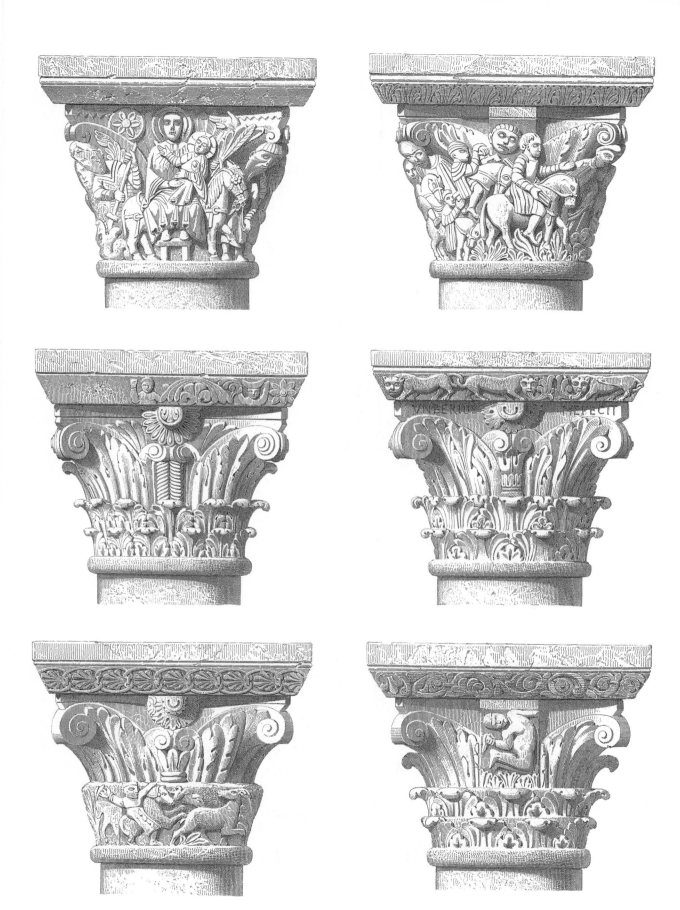

9. Porch Capitals, Abbey Church at St. Benoit Sur Loire, France

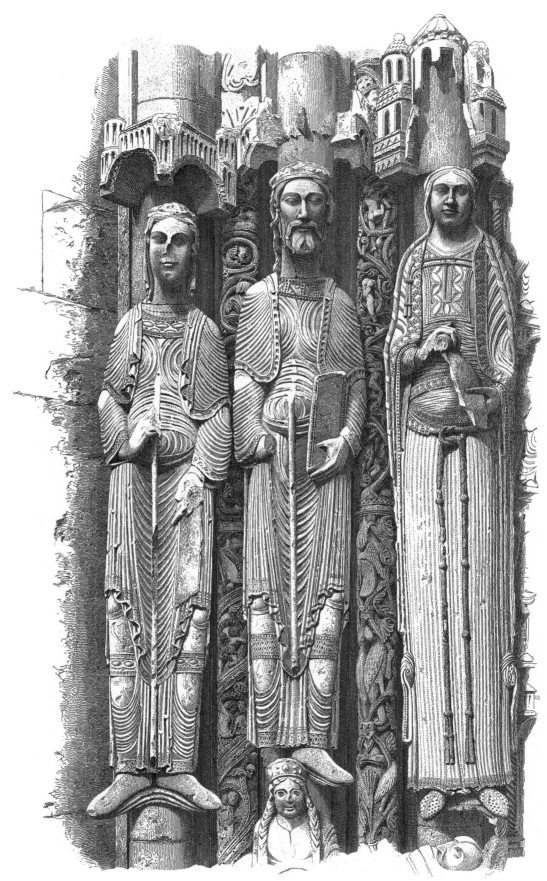

10. Details of Facade, Chartres Cathedral, France

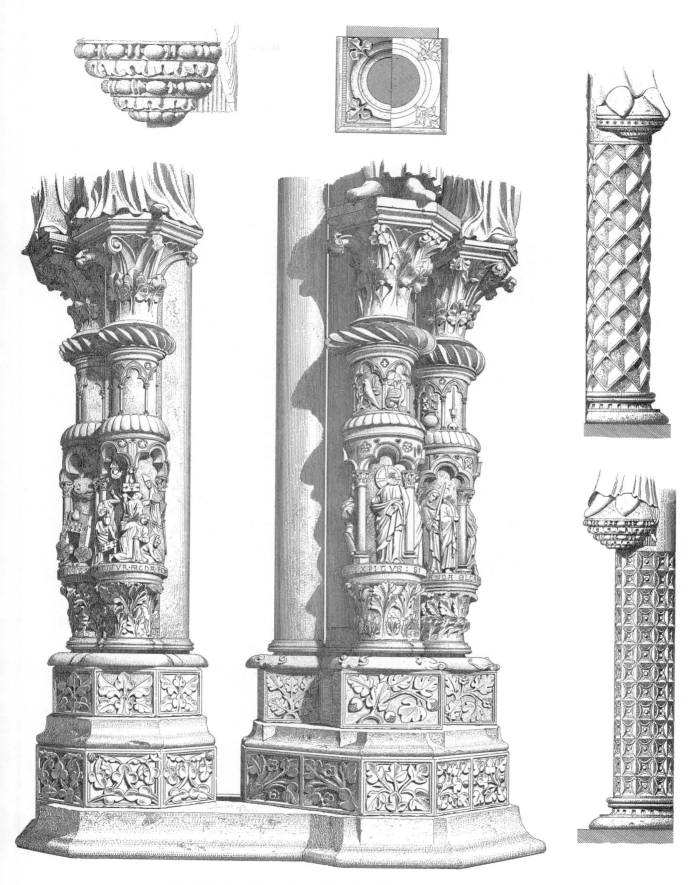

11. Details of Facade and Porch, Chartres Cathedral, France

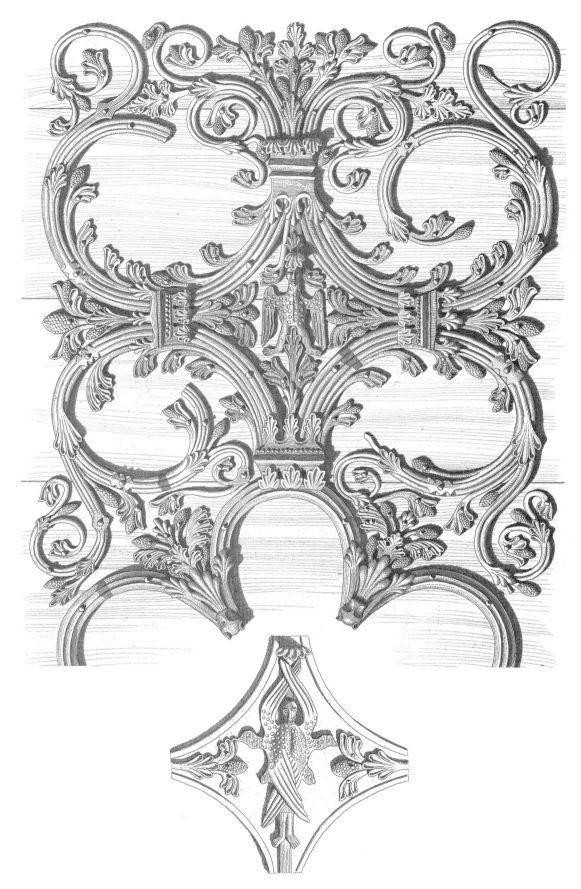

12. Ironwork, St. Anne's Doorway, Cathedral of Notre Dame, Paris

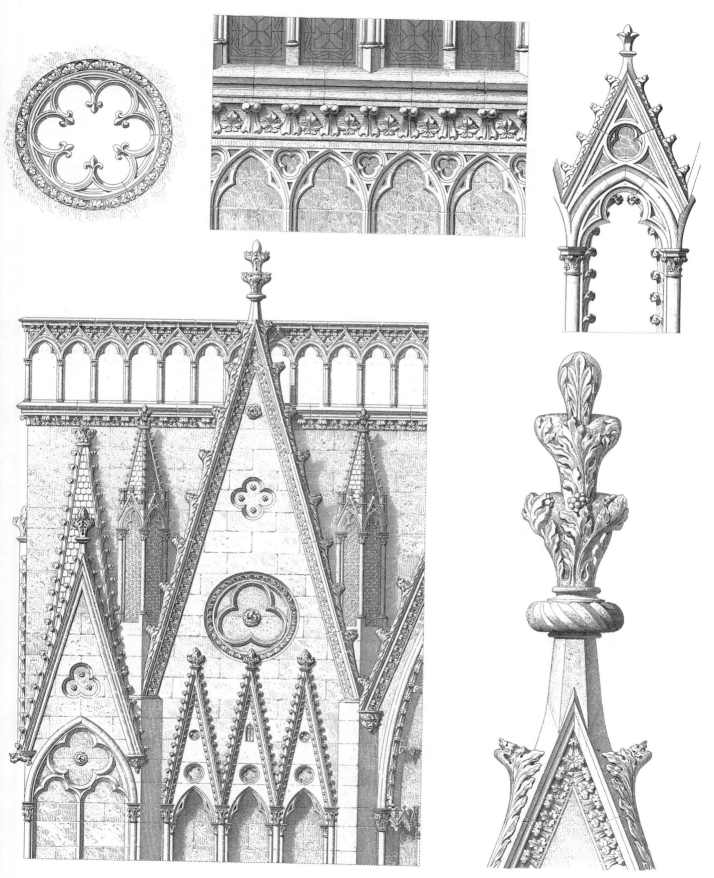

13. Details, Transept, Cathedral of Notre Dame, Paris

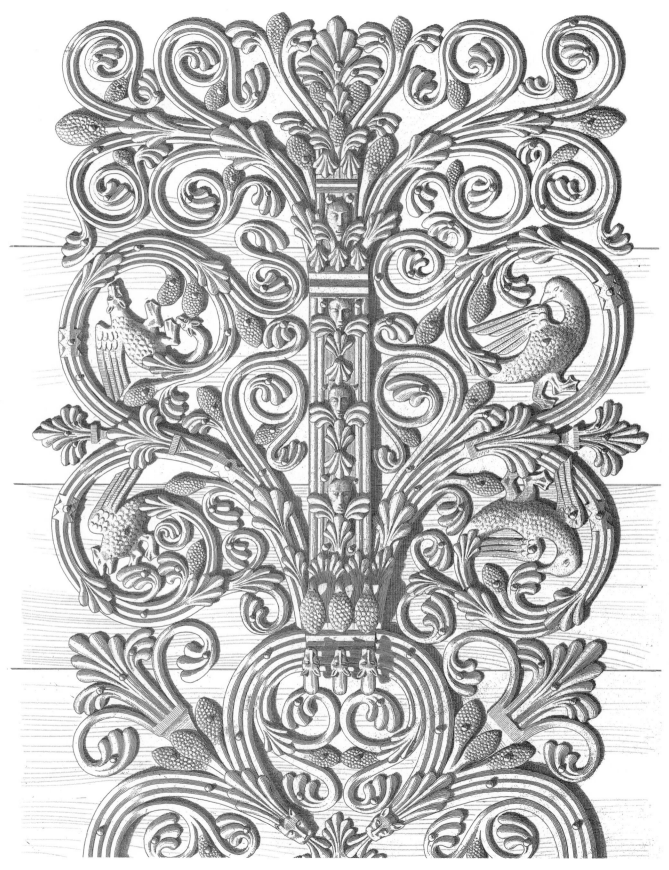

14. Ironwork, St. Anne's Doorway, Cathedral of Notre Dame, Paris

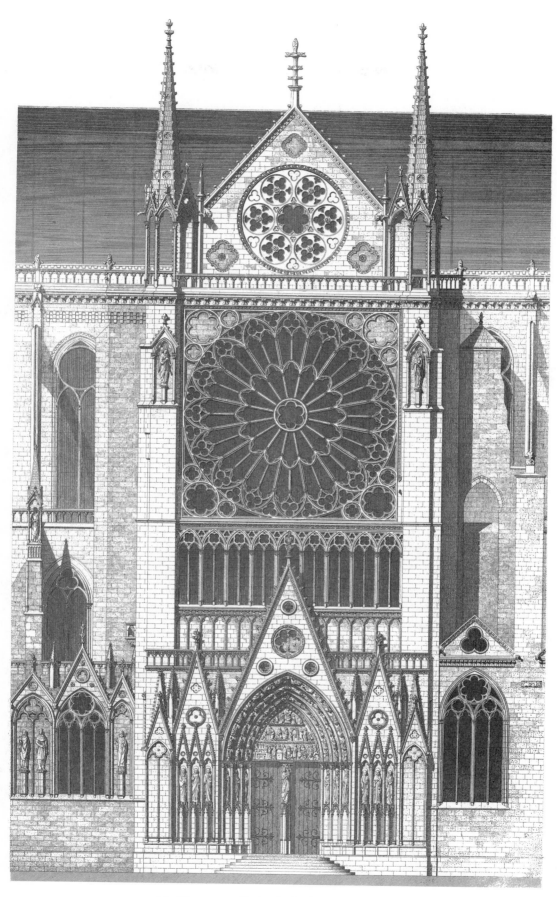

15. Transept, Cathedral of Notre Dame, Paris

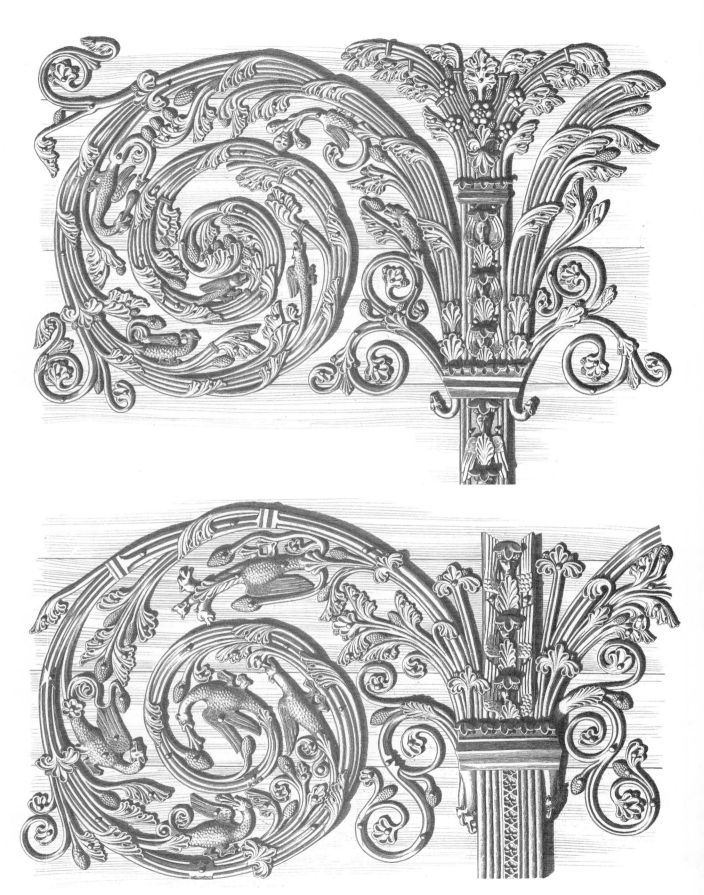

16. Ironwork, St. Anne's Doorway, Cathedral of Notre Dame, Paris

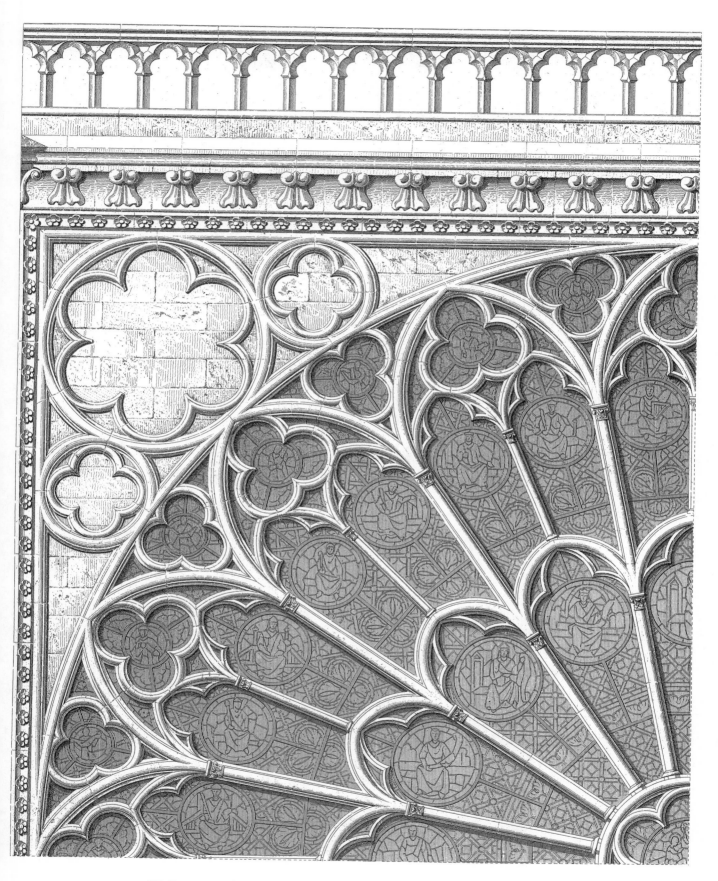

17. Rose Window, North Transept, Cathedral of Notre Dame, Paris

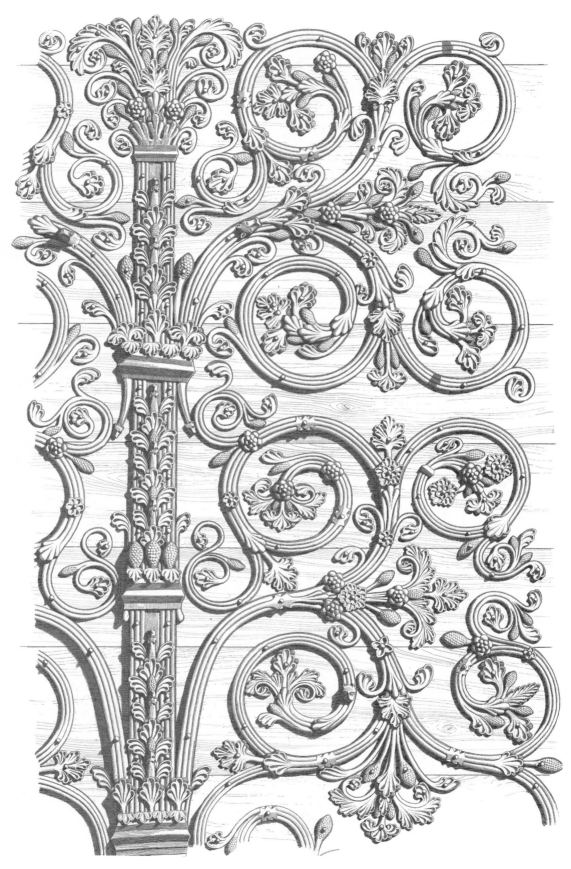

18. Ironwork, St. Anne's Doorway, Cathedral of Notre Dame, Paris

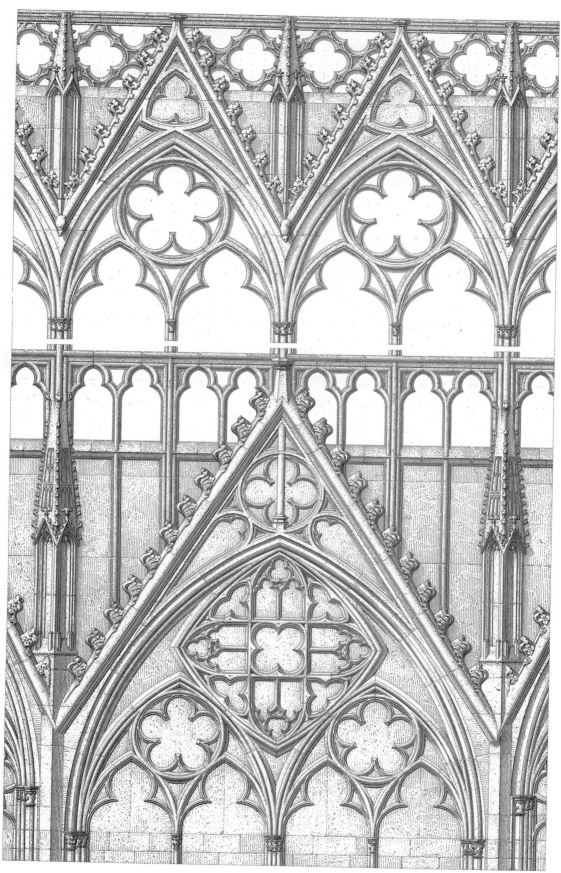

19. Interior Decoration, North Transept, Meaux Cathedral, France

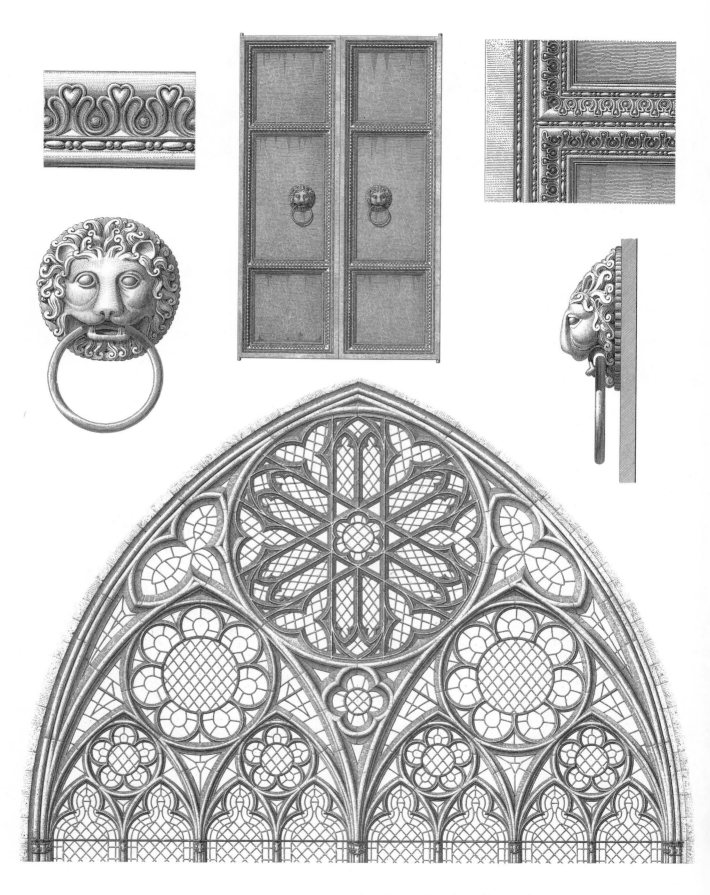

20. Bronze Door Ornaments, Notre Dame Church, Aix-la-Chapelle (Aachen), Germany;
Interior Decoration, North Transept, Meaux Cathedral, France

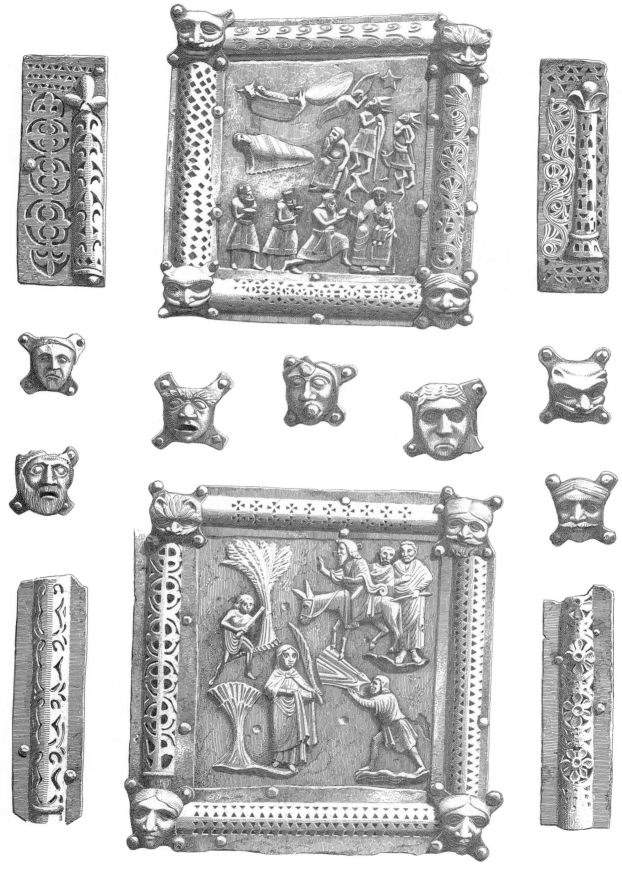

21. Door Decorations, Church of St. Zenon, Verona, Italy

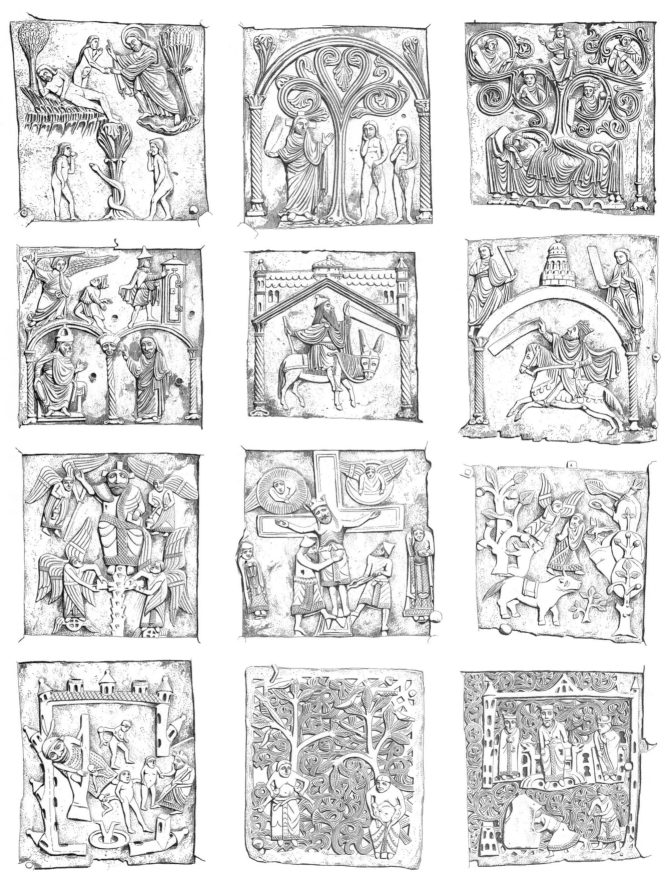

22. Details of Door Decorations, Church of St. Zenon, Verona, Italy

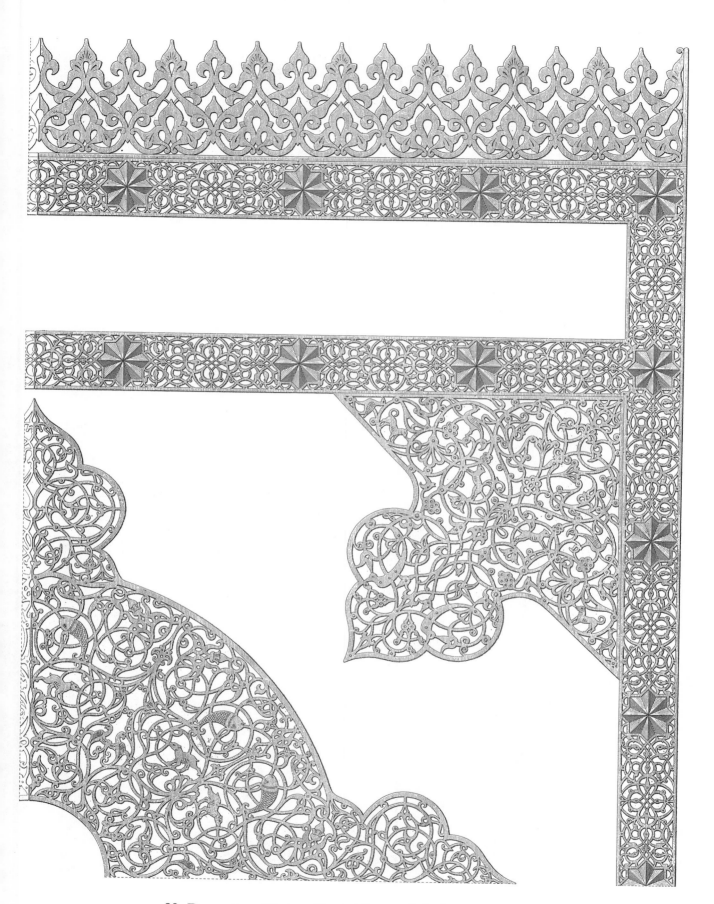

23. Decoration, Western Door, Mosque d'el Khânqeh, Egypt

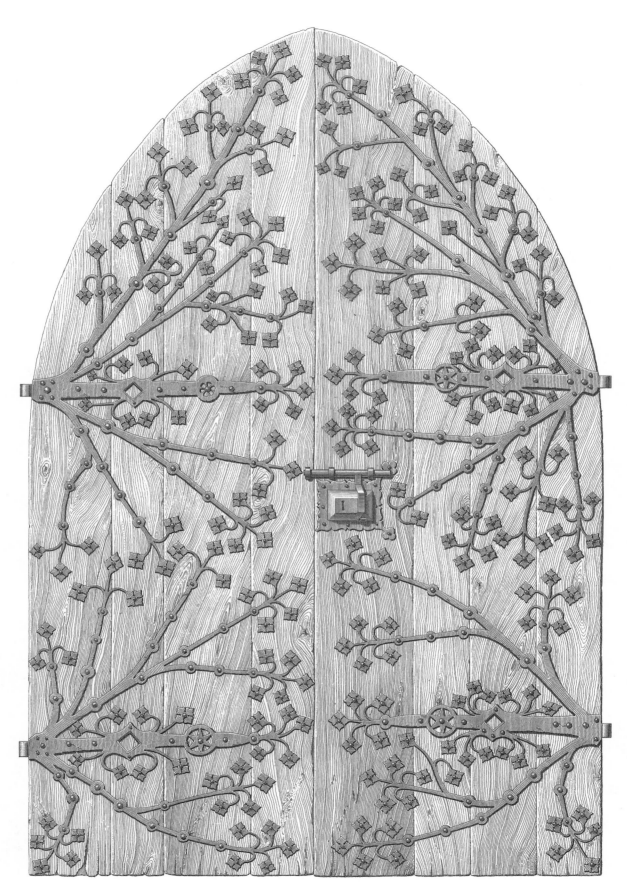

24. Ironwork of Door, Lahneck Chateau, Germany

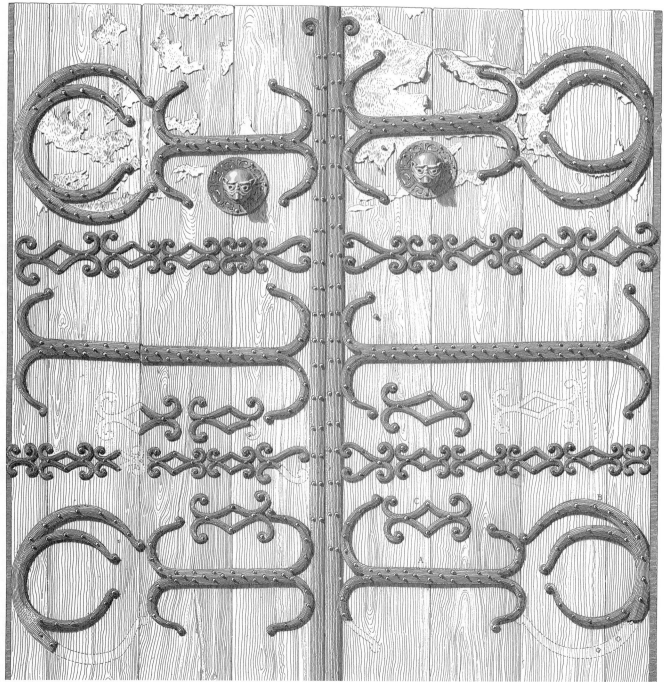

25. Door Decorations, Puy Cathedral, France

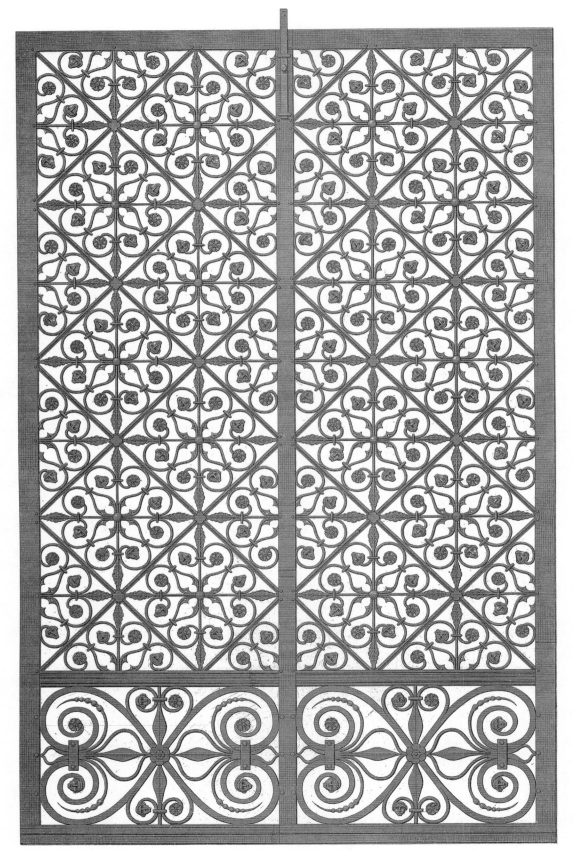

26. Iron Door, Rouen, France

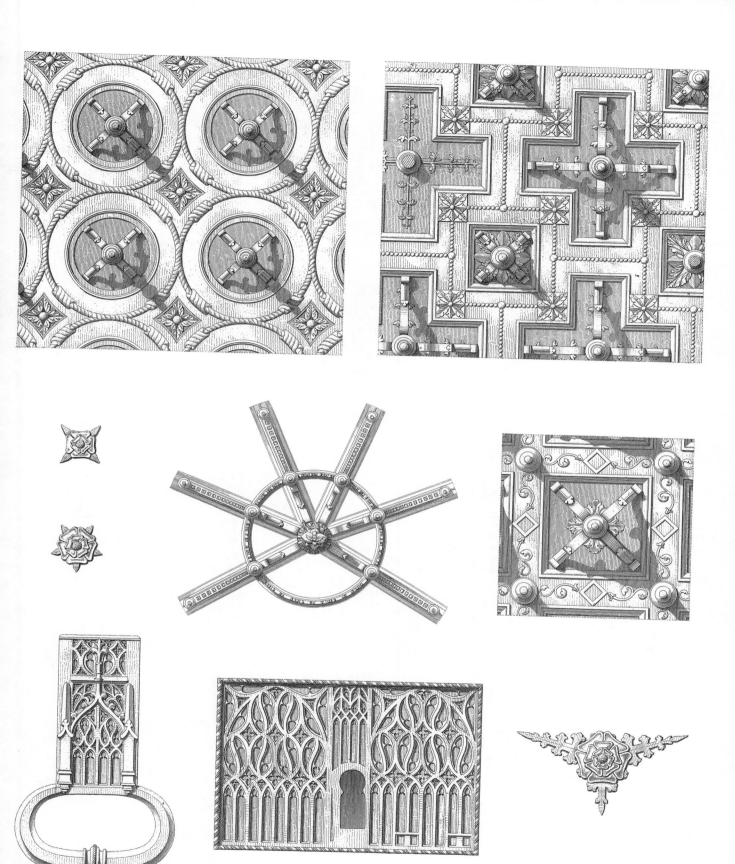

27. Ceiling Decorations, Chapel of the Virgin, Church of Fort Bernard, France;
Decorations, Sacristy Door, Rouen Cathedral, France

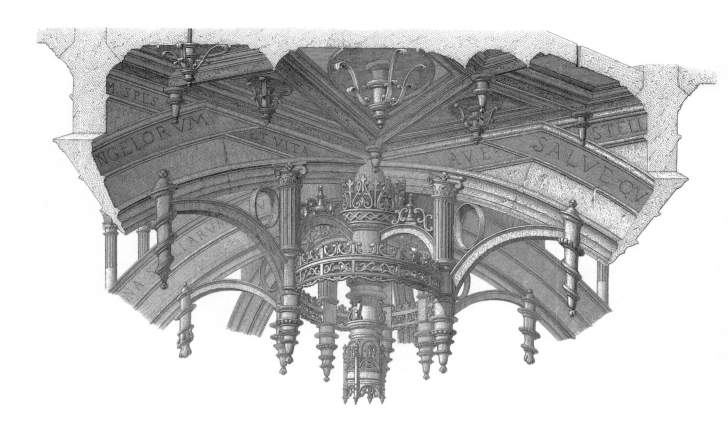

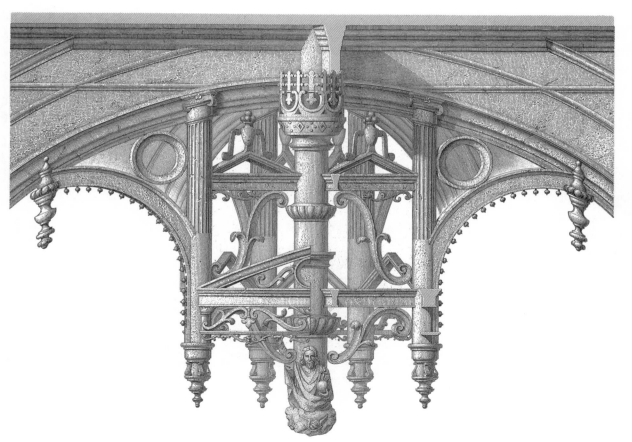

28. Pendants, Chapel of the Virgin, Church of Fort Bernard, France

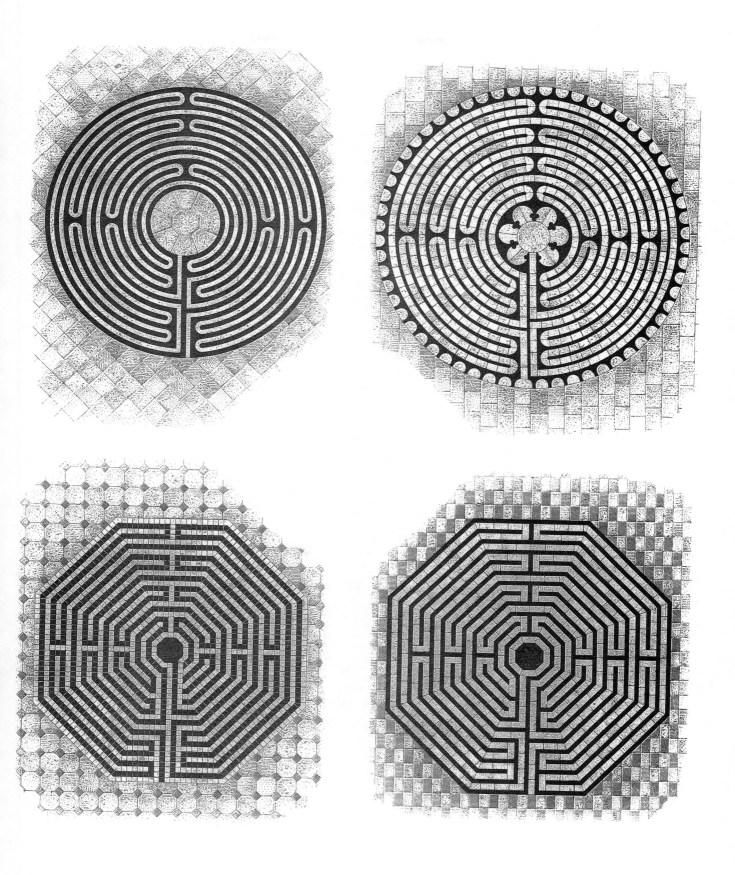

29. Labyrinths in the Cathedrals of Sens, Chartres, St. Quentin, and Amiens, France

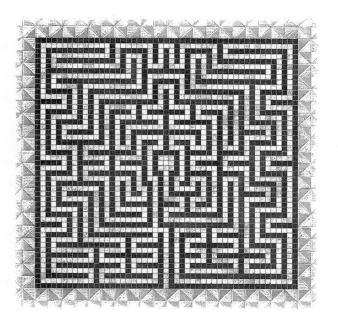
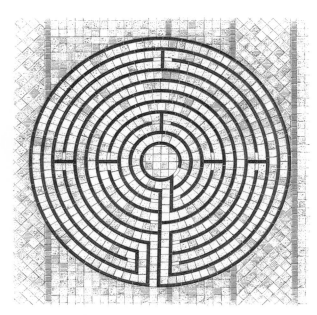
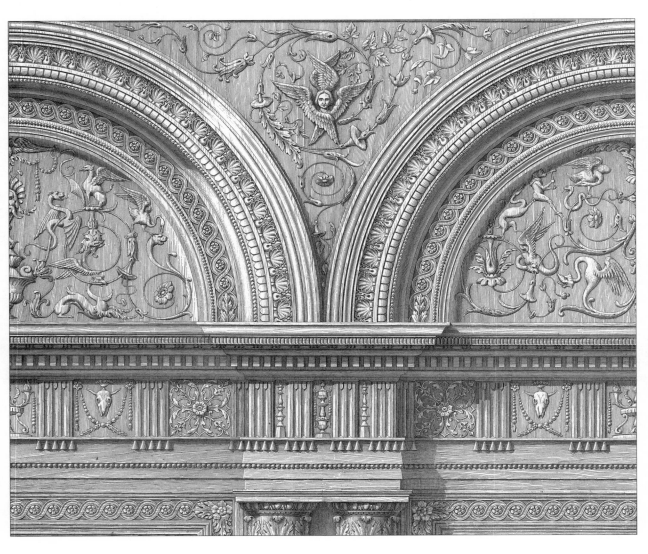

30. Labyrinths in the Cathedrals of St. Omer and Reims, France; Details of Woodwork,
Sacristy of the Church of Santa Maria in Organo, Verona, Italy

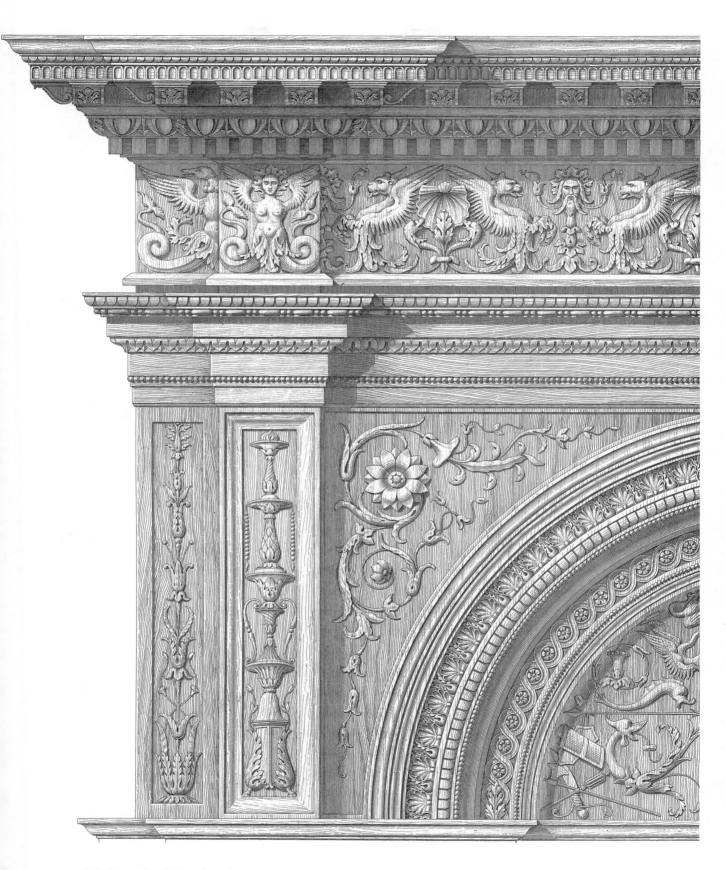

31. Details of Woodwork, Sacristy of the Church of Santa Maria in Organo, Verona, Italy

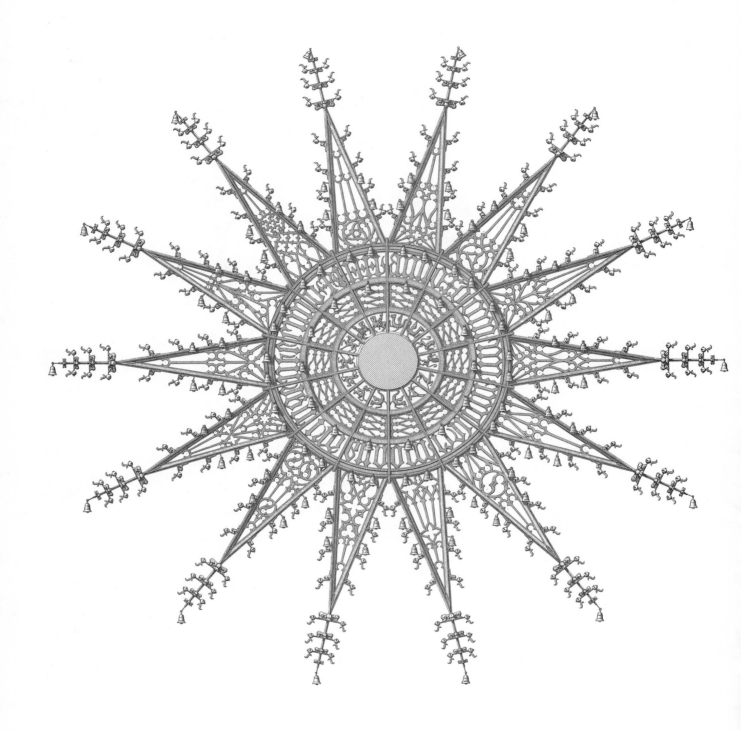

32. Bell-Ringing Mechanism, Abbey Church, Fulda, Germany

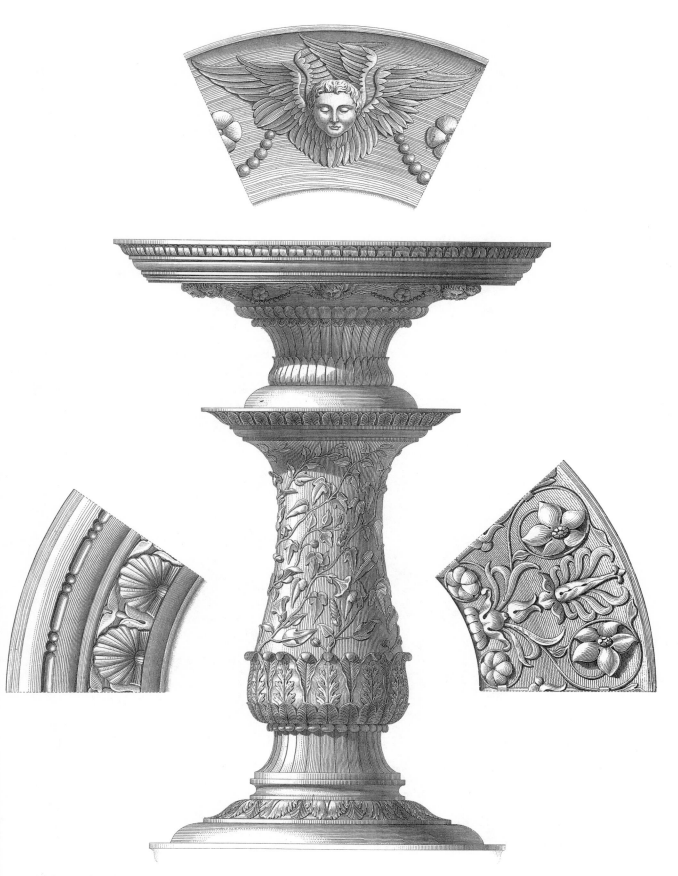

33. Details of Candelabra for the Paschal Candle, Church of Santa Maria in Organo, Verona, Italy

34. Details of Stalls, Church of St. Peter, Pérouse, France

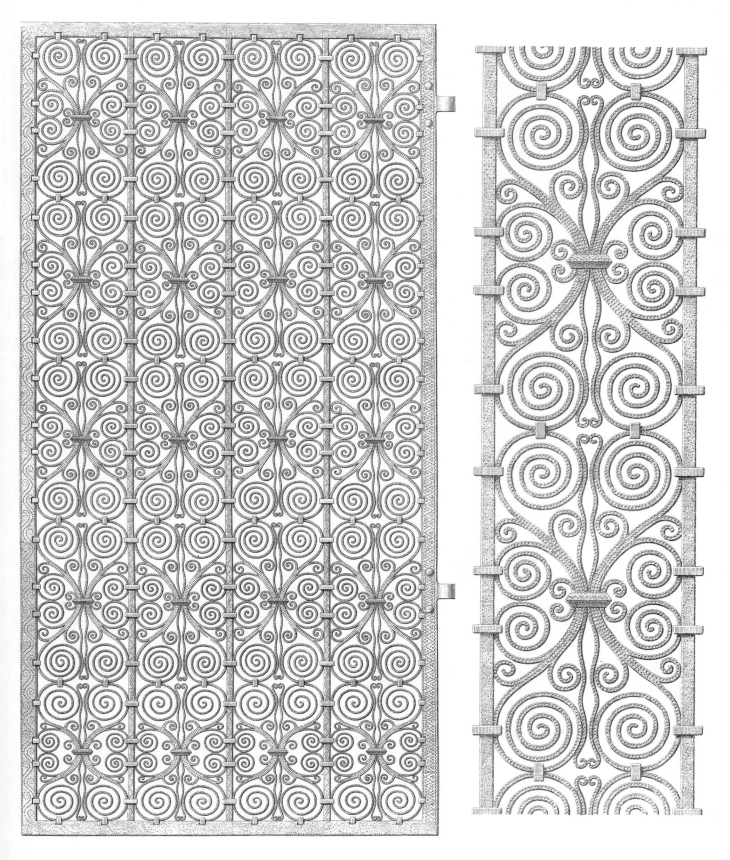

35. Decoration of Door, Cathedral Church, Puy, France

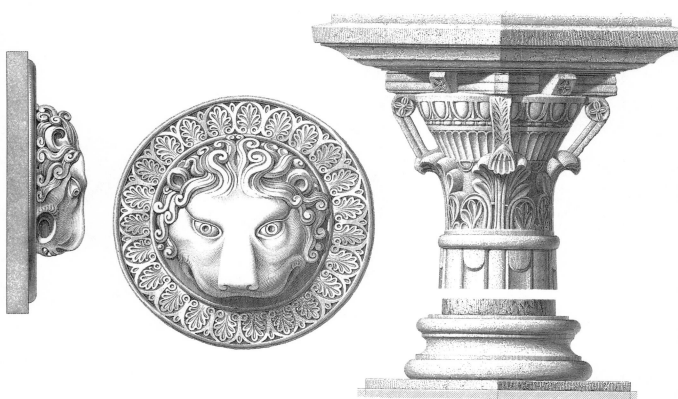

36. Details of Bronze Door Decoration, Church of Notre Dame, Aix-La-Chapelle
(Aachen), Germany; Capital, Crypt at Jouarre, France

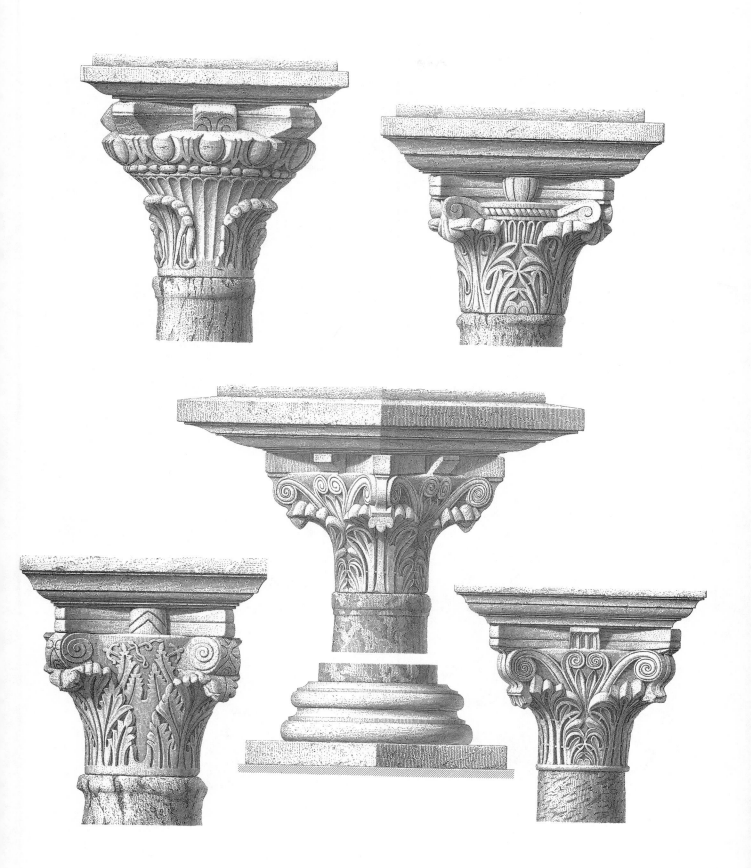

37. Capitals, Crypt at Jouarre, France

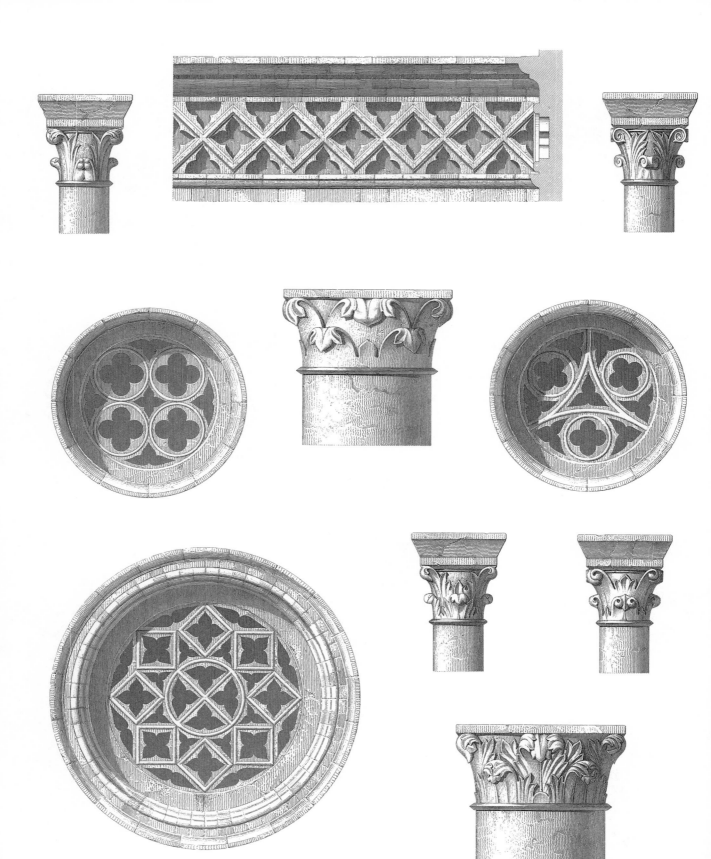

38. Details, Visconti Residence, Pavia, Italy

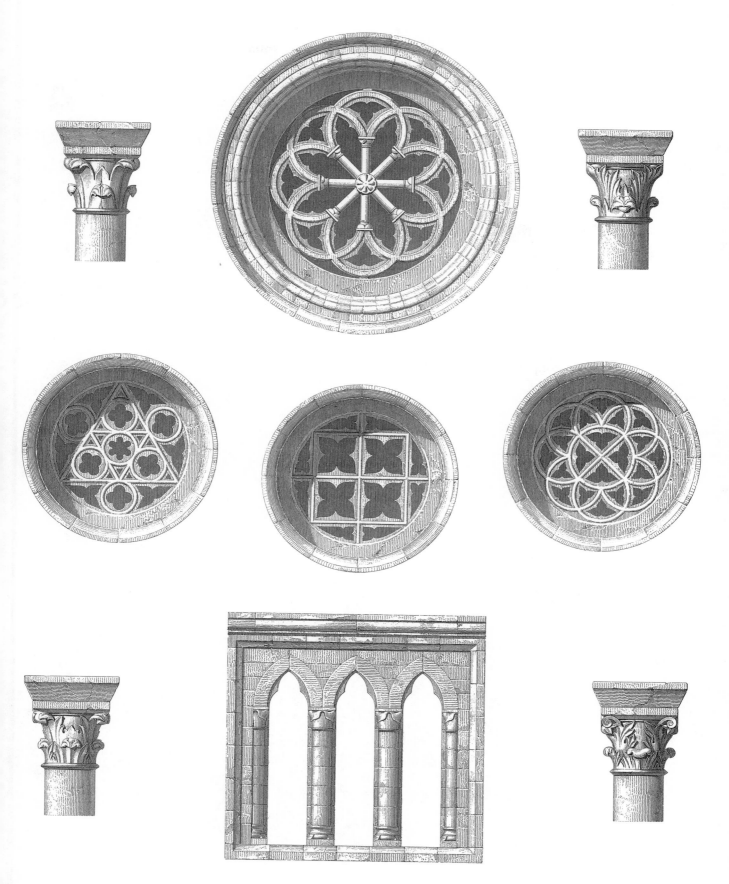

39. Details, Visconti Residence, Pavia, Italy

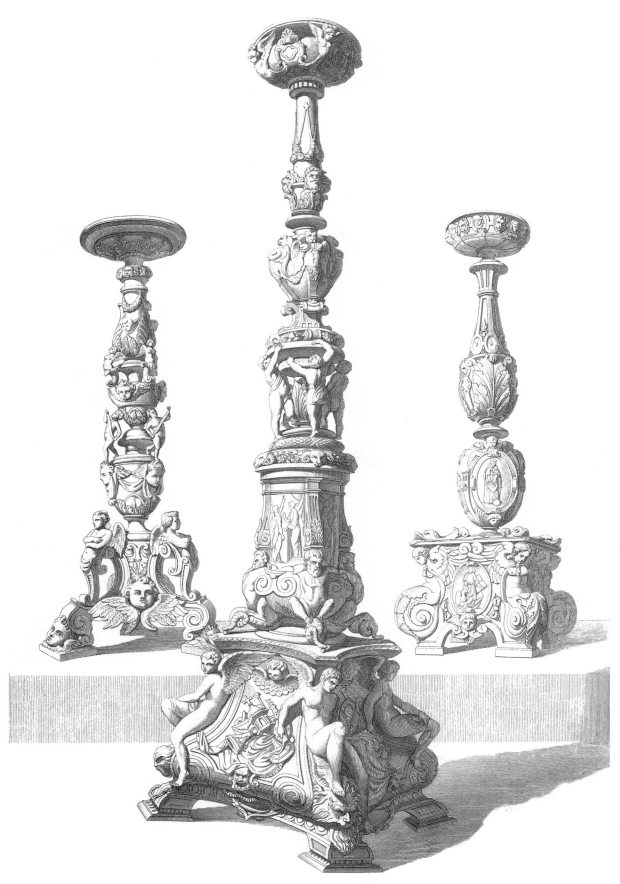

40. Candelabra and Candlesticks, Italy

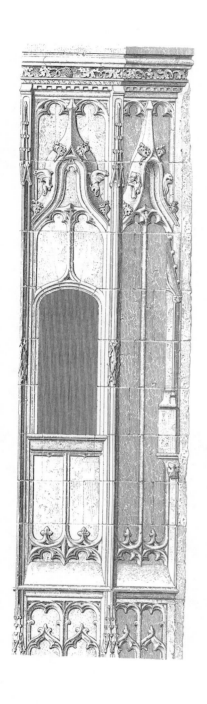
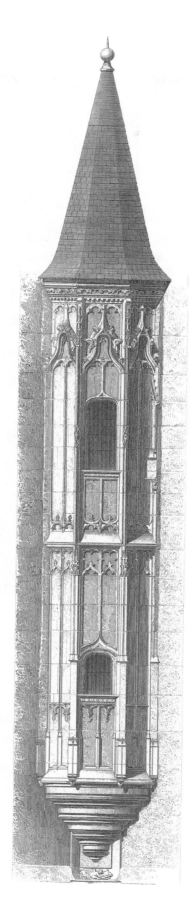
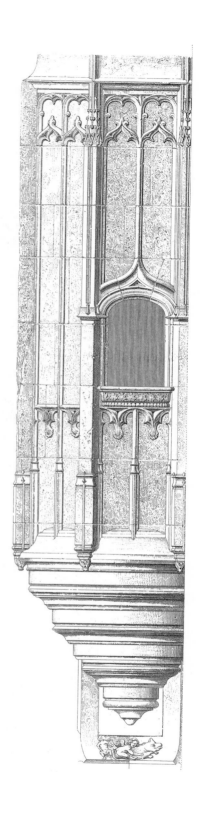

41. Turret, Place de la Grève, Paris

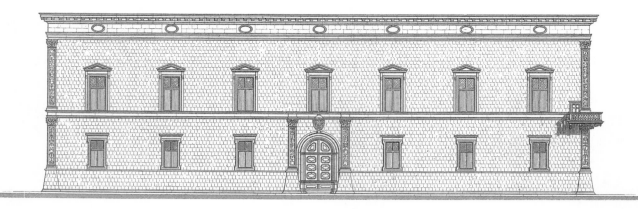

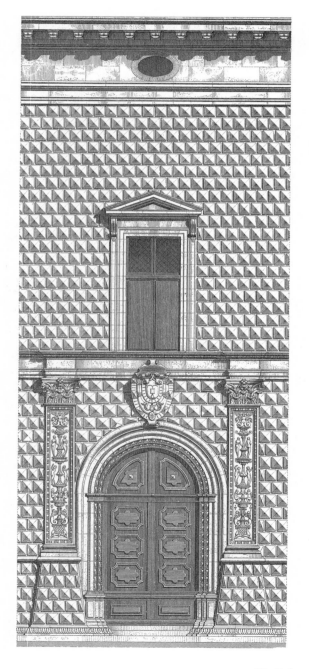

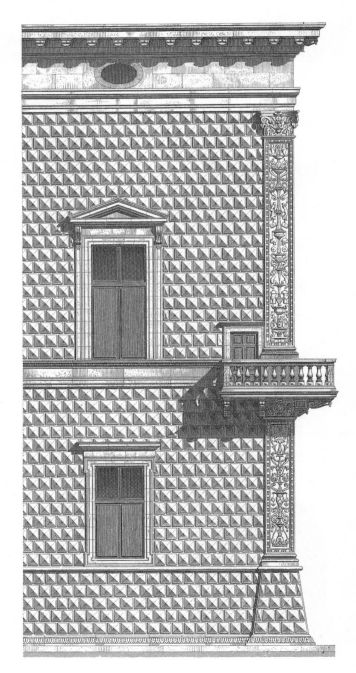

42. Palace, Ferrara, Italy

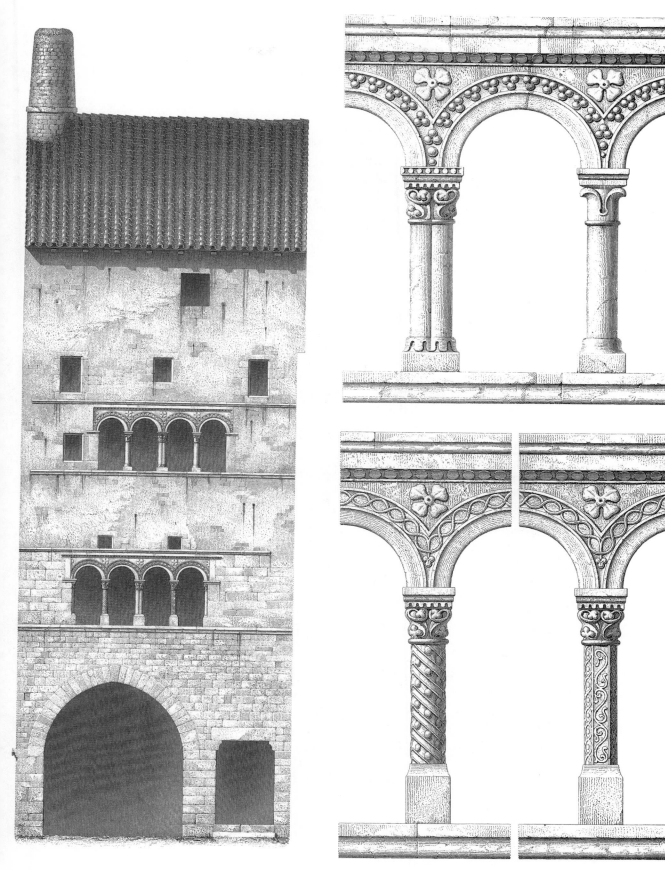

43. House, Cluny, France

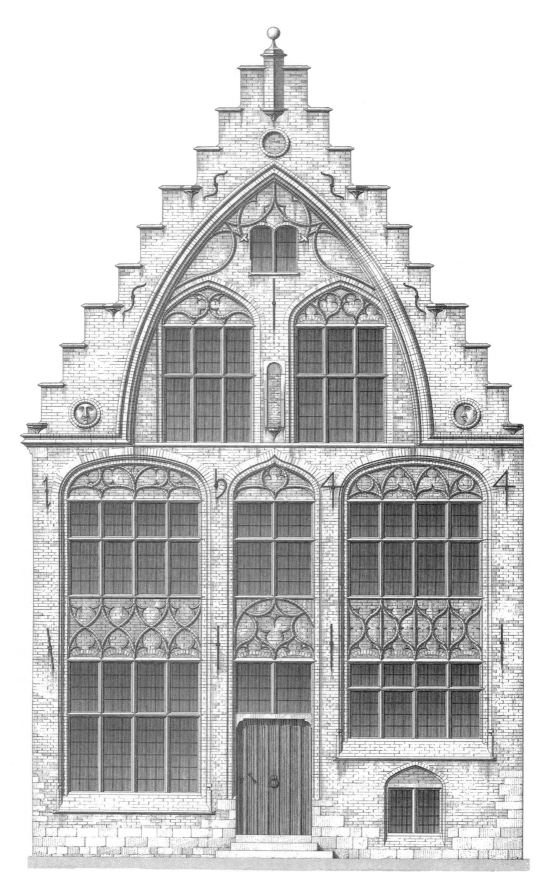

44. Brick House, Ypres, Belgium

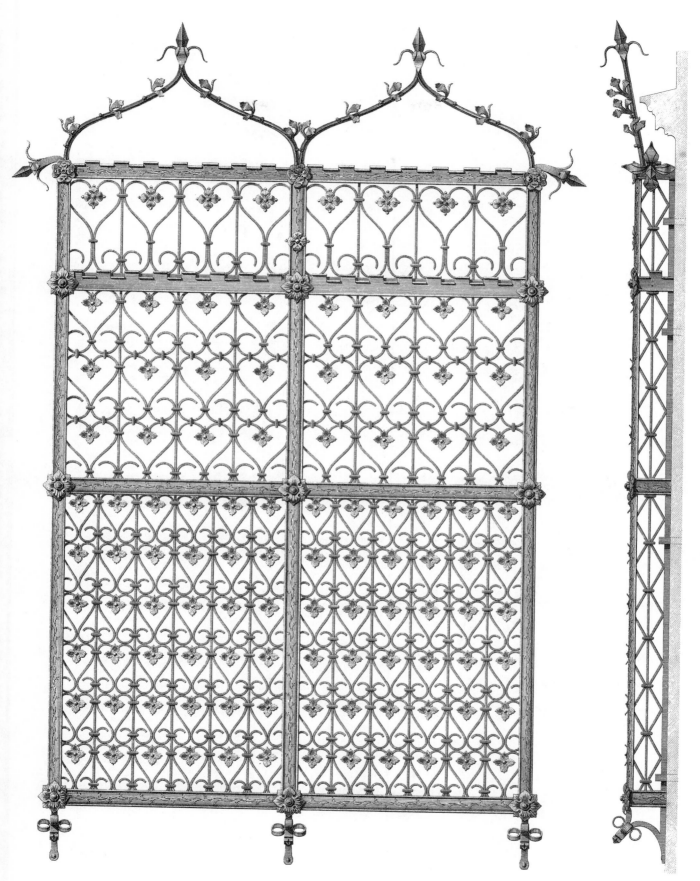

45. Window Grill of a House, Street of the Golden Hammer, Troyes, France

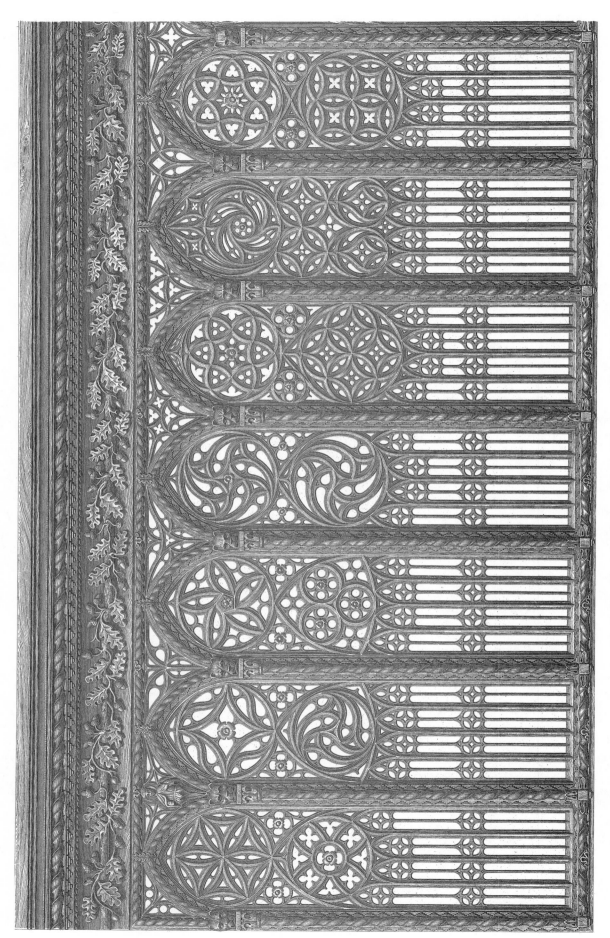

46. Stalls, Church of Santa Maria Gloriosa de Frari, Venice

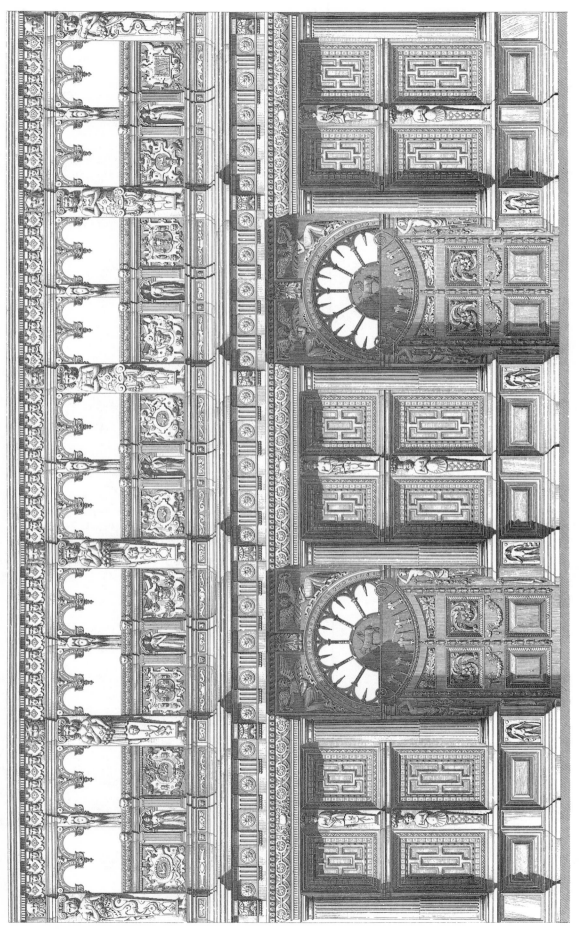

47. Wooden Enclosure, Hall of the Middle Temple, London

48. Details of the Enclosure, Hall of the Middle Temple, London

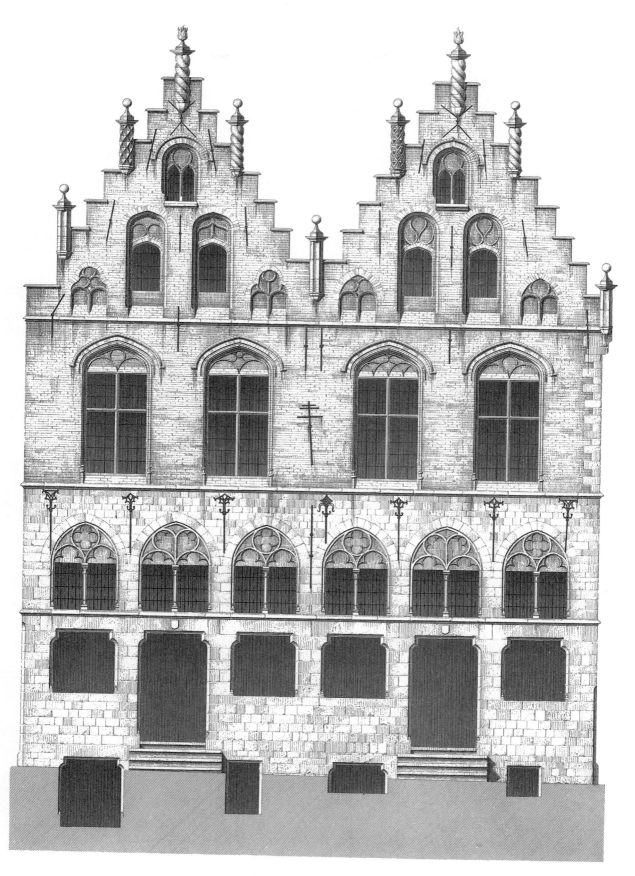

49. Butcher Shops, Ypres, Belgium

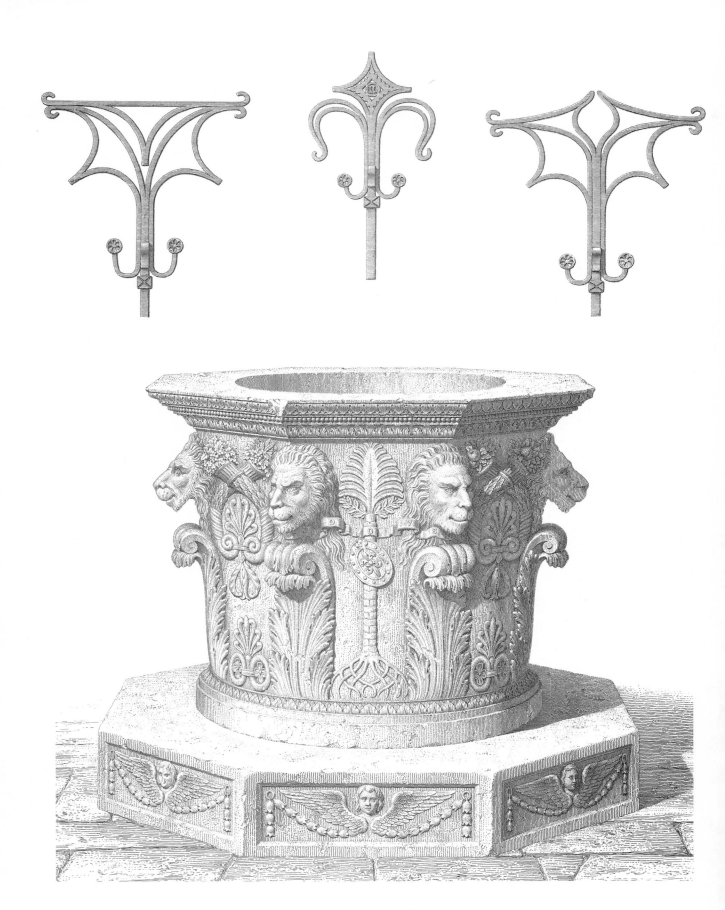

50. Details of Butcher Shops, Ypres, Belgium; Lip of a Well at a Venetian House

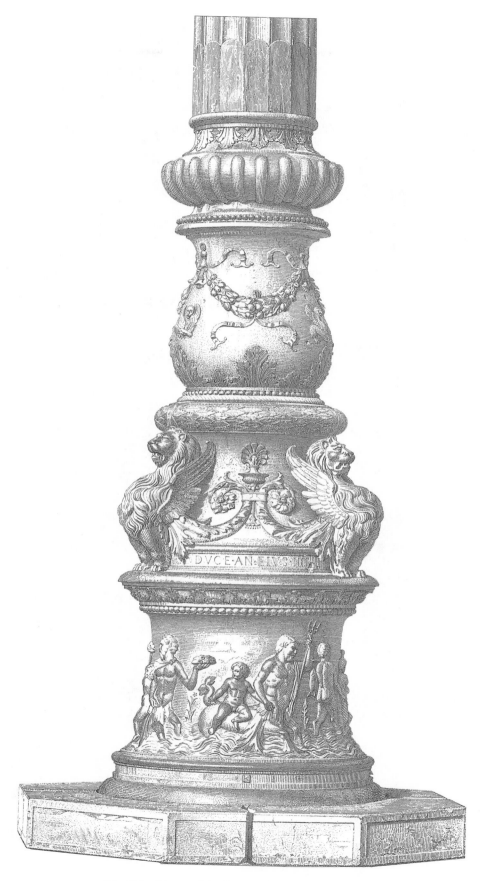

51. Pole Erected in St. Mark's Square, Venice

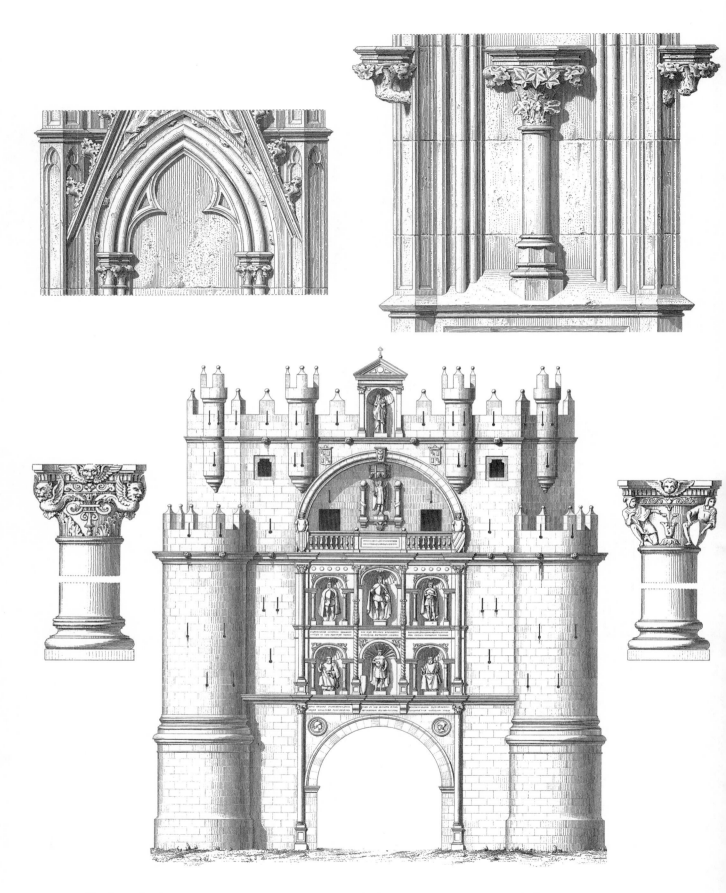

52. Details, Commemorative Monument, Godesberg, Germany; Triumphal Gate, Burgos, Spain

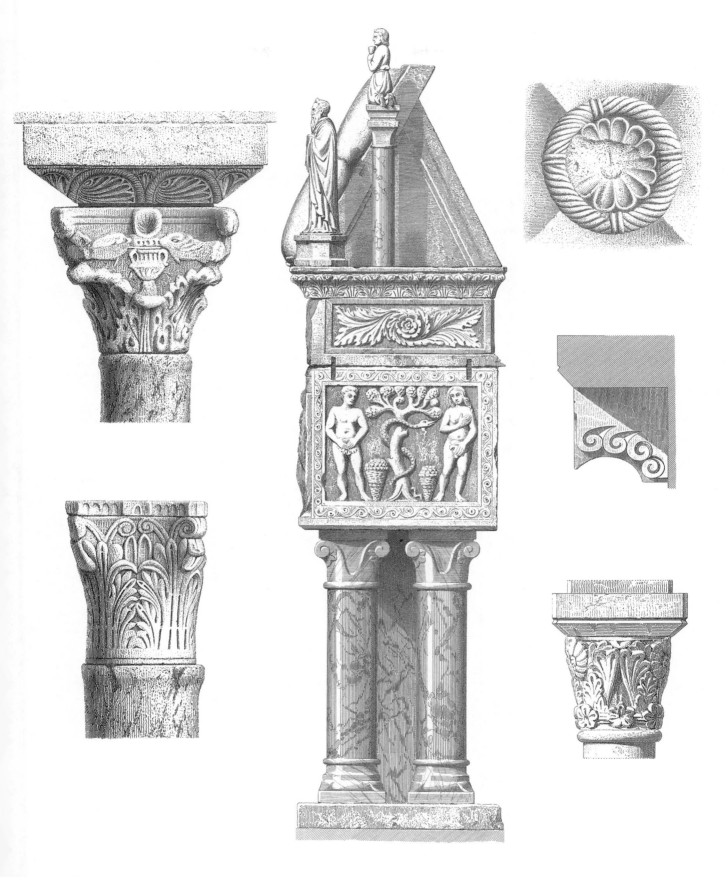

53. Details, Crypt and Chapel at Jouarre, France; Details, Sepulchral Chapel, Chambon, France;
Tomb of Saints Simeon and Jude, Church of St. Jean-in-Valle, Verona, Italy

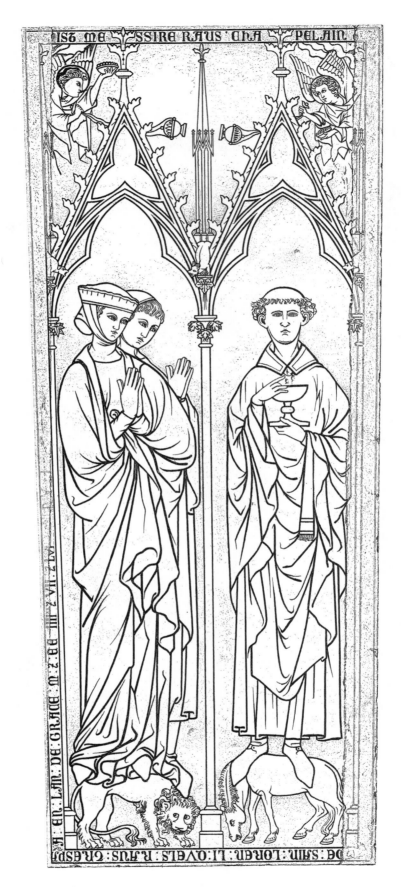

54. Memorial Stone, Cathedral Church, Chalons-Sur-Marne, France

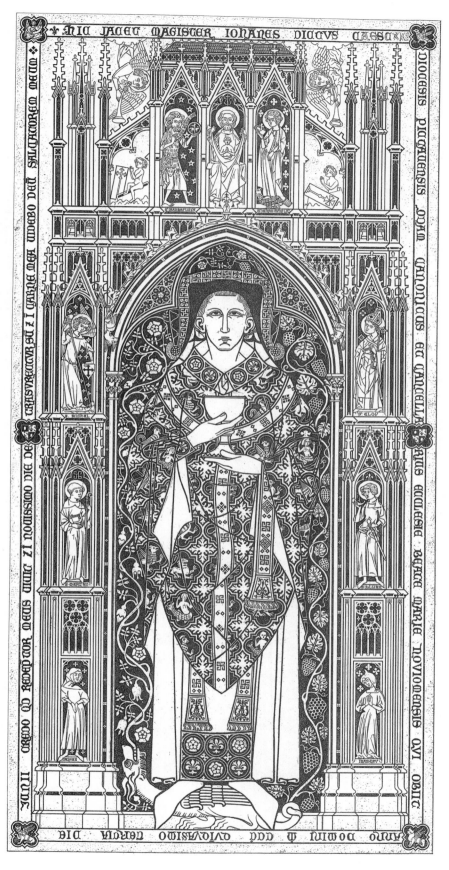

55. Memorial Stone of a Canon, formerly in the Church of Saint Genevieve,
now in The School of Beaux Arts, Paris

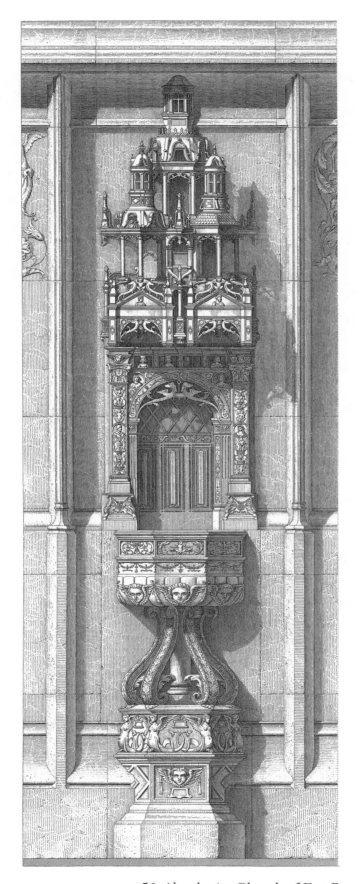
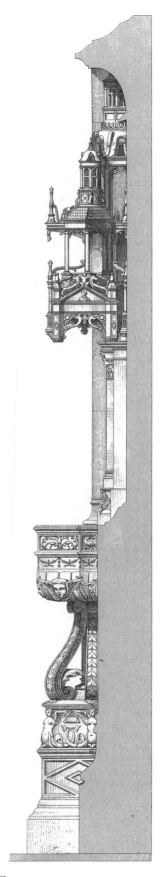

56. Altar basin, Church of Fort Bernard, France

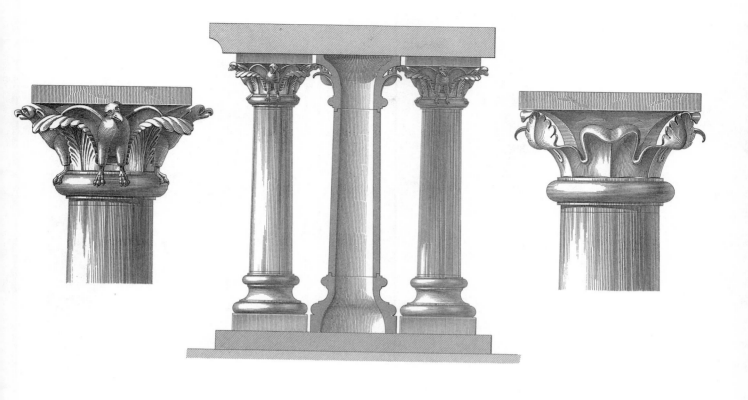

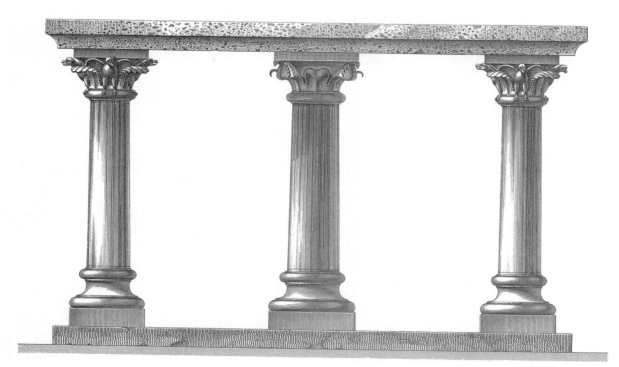

57. Bronze Altar, Brunswick Cathedral, Germany

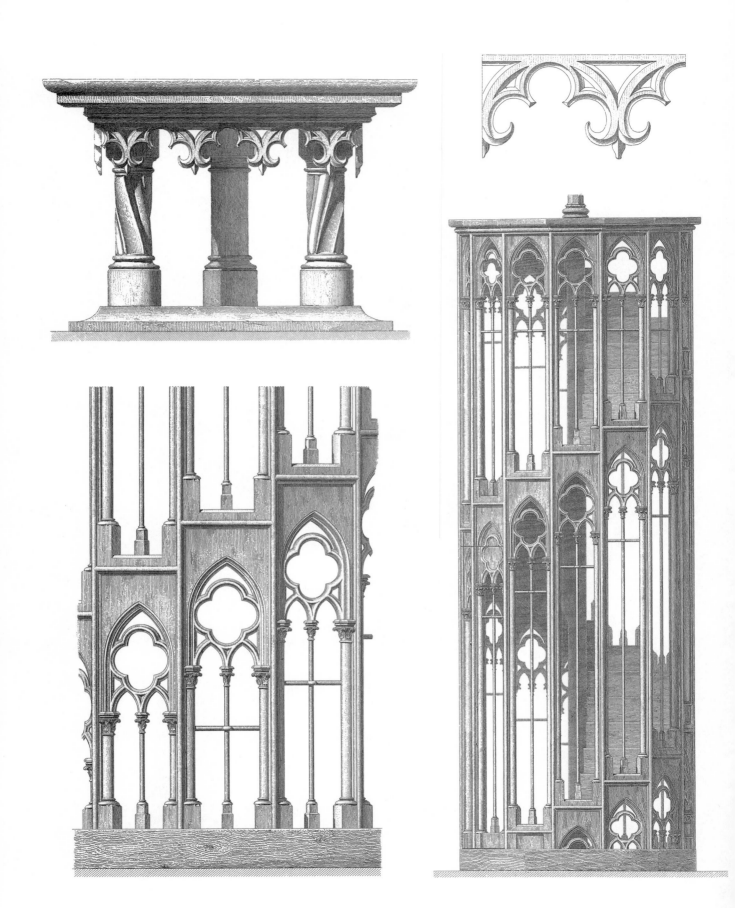

58. Altar and Altar Detail, Norrey, France; Details of Miniature Temple for
Display of Relics in the Palatine Chapel, Paris

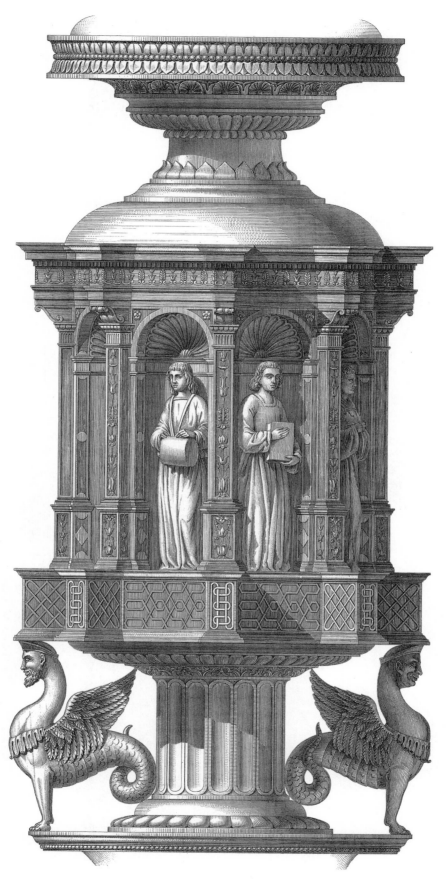

59. Candelabra for the Paschal Candle, Church of Santa Maria in Organo, Verona, Italy

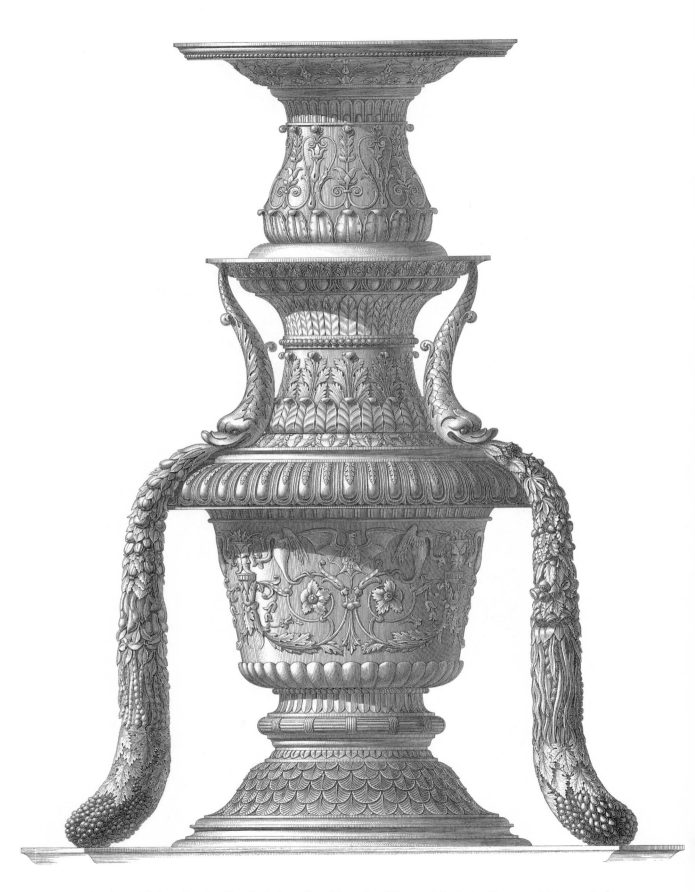

60. Candelabra for the Paschal Candle, Church of Santa Maria in Organo, Verona, Italy

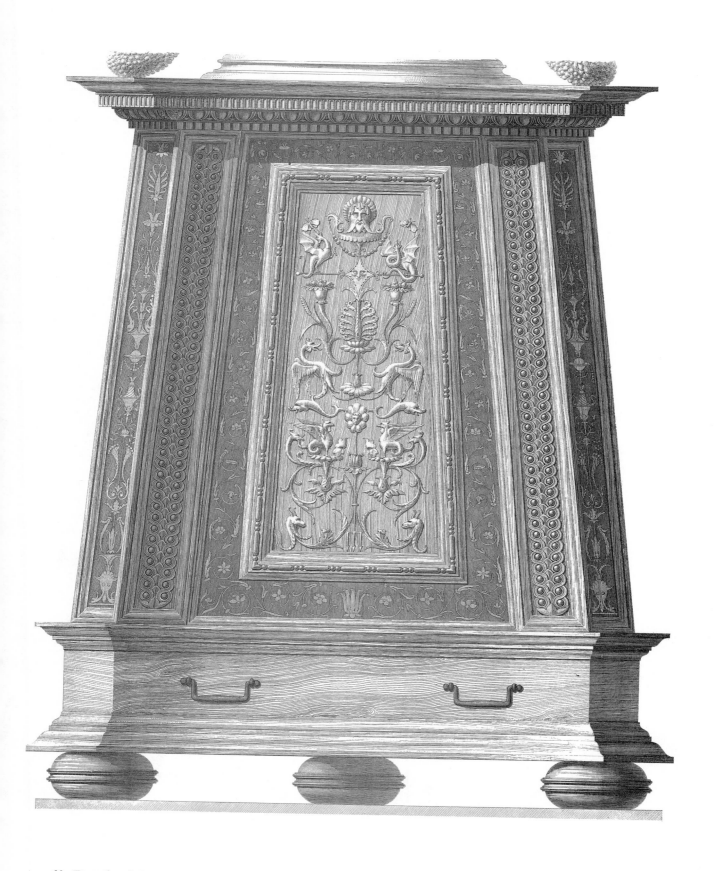

61. Details of Candelabra for the Paschal Candle, Church of Santa Maria in Organo, Verona, Italy

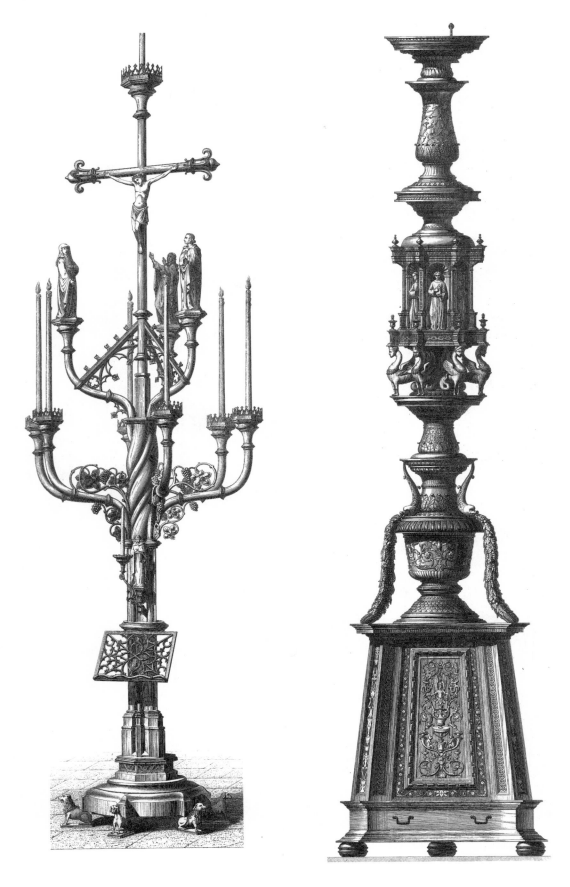

62. Candelabra with Seven Branches in the Church of Léau, Belgium; Candelabra for the
Paschal Candle, Church of Santa Maria in Organo, Verona, Italy

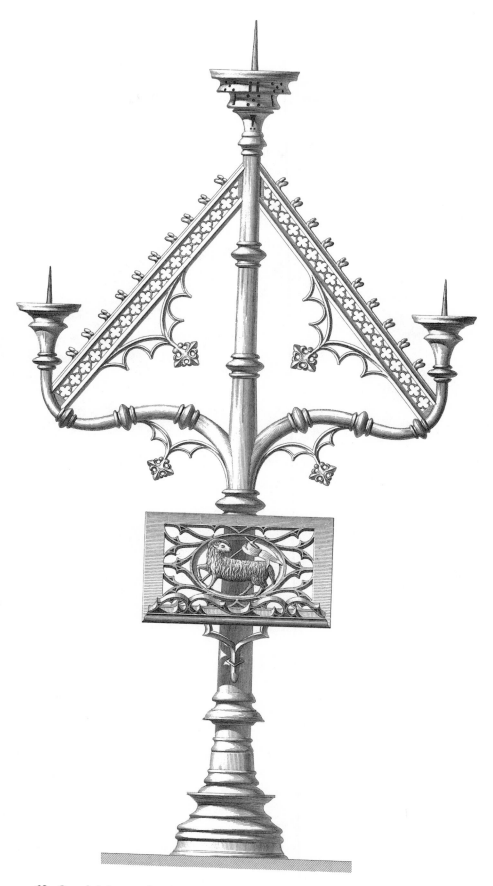

63. Candelabra with Three Branches, Church of Gaurain, Belgium

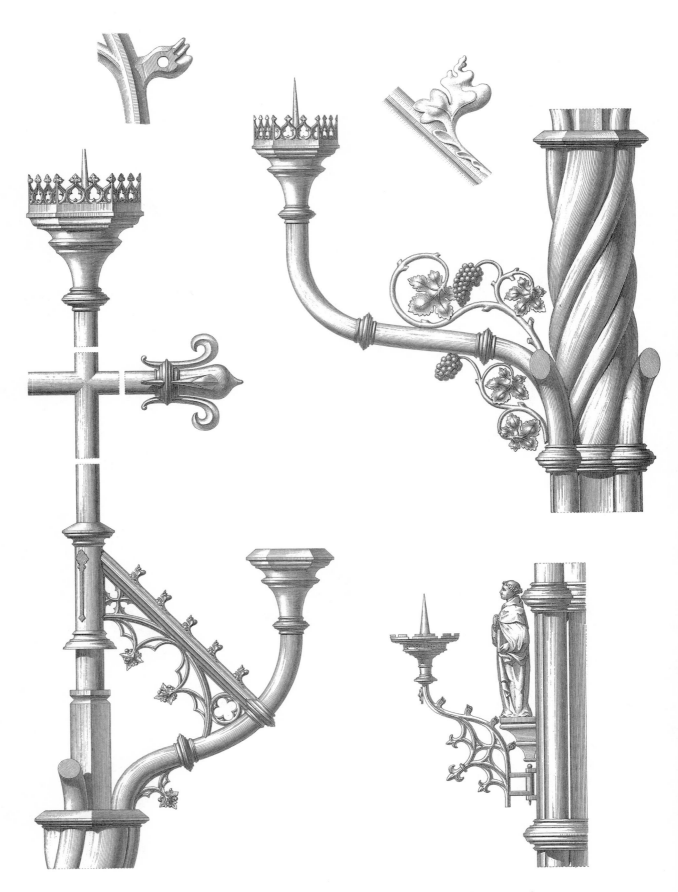

64. Details of Candelabra with Seven Branches, Church of Léau, Belgium

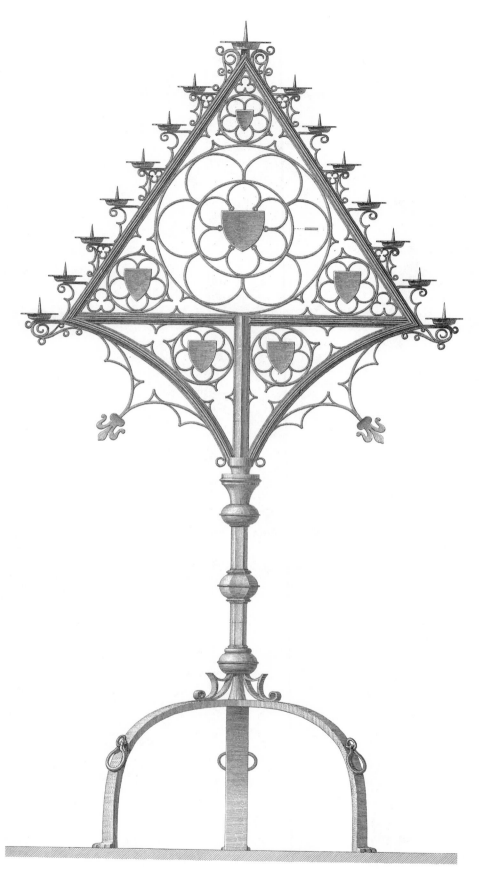

65. Candelabra for the Tenebrae, Cathedral Church, Osnabruck, Germany

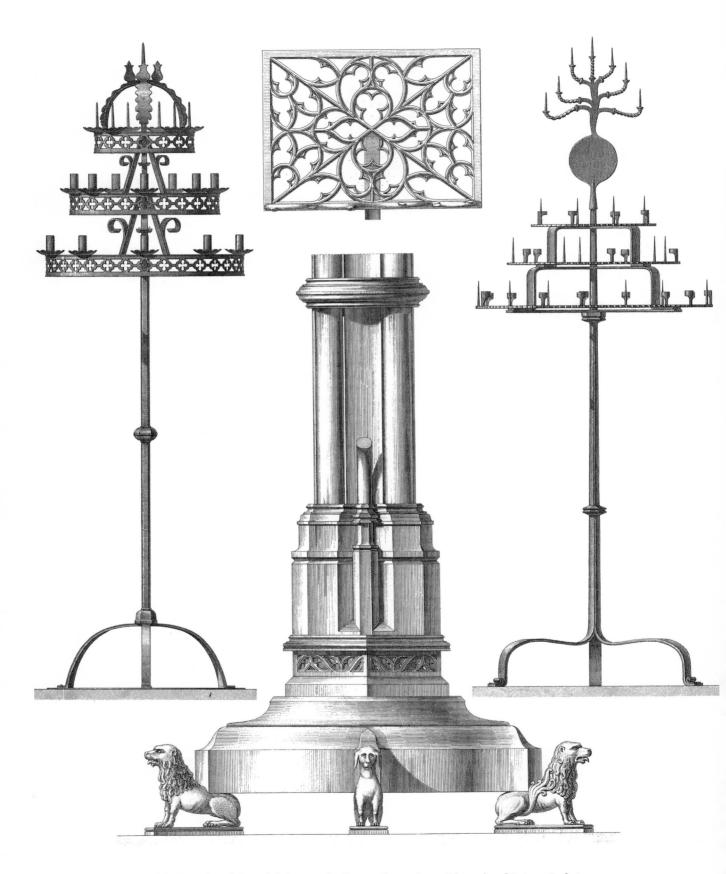

66. Details of Candelabra with Seven Branches, Church of Léau, Belgium;
Candle stands at Tournai and Lierre, Belgium

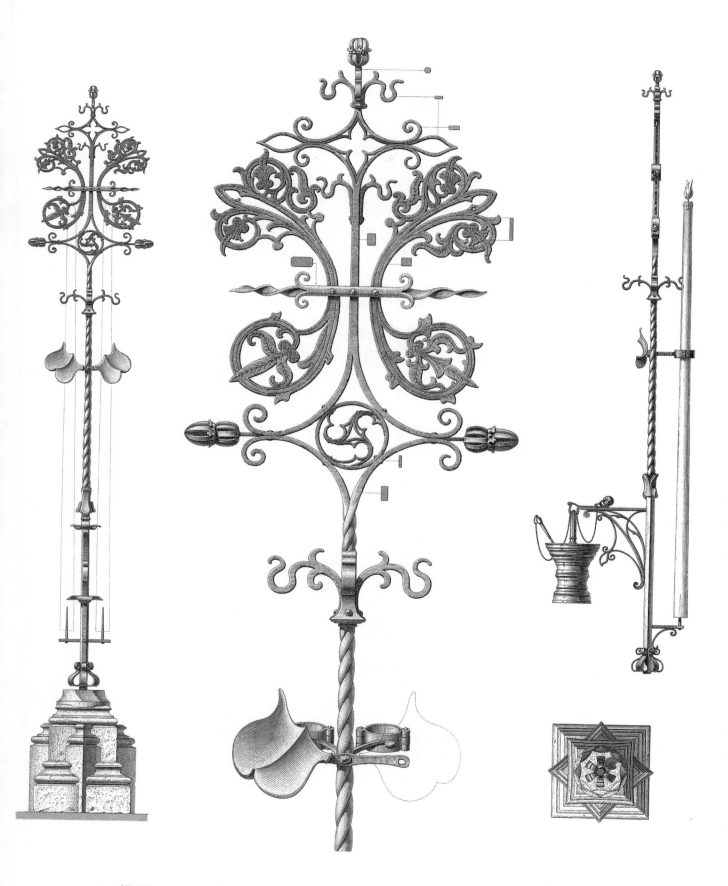

67. Funerary Lighting Utensils, Church of Ste. Colombe, Cologne, Germany

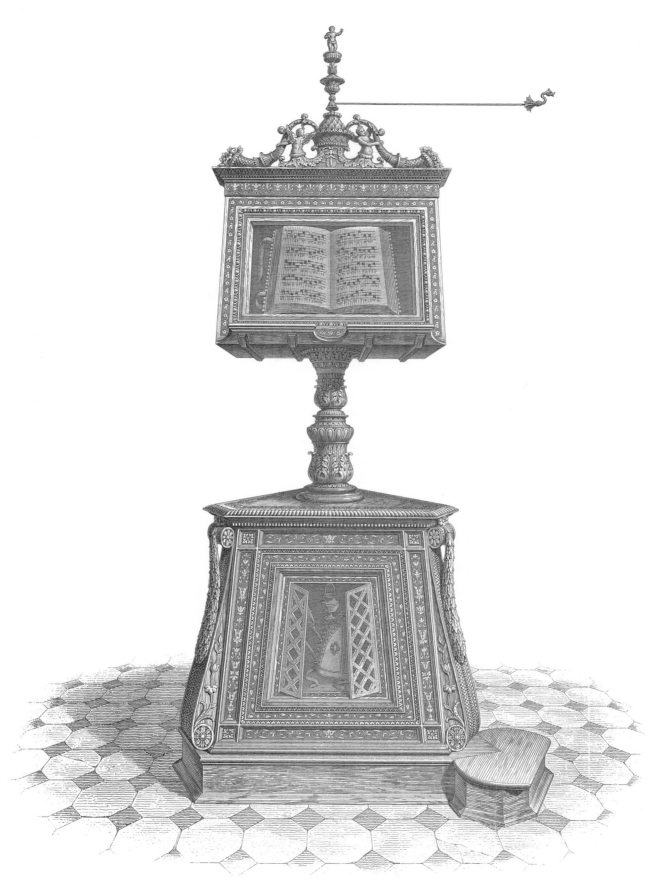

68. Lectern, Church of Santa Maria in Organo, Verona, Italy

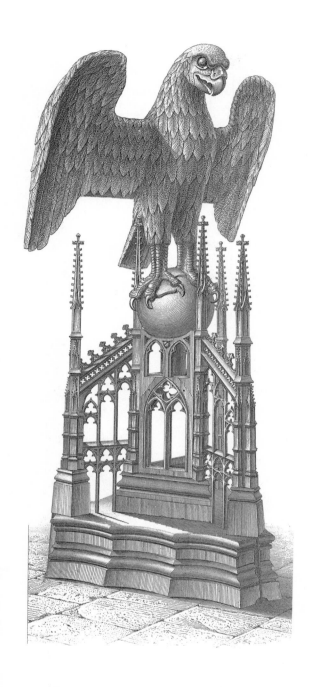
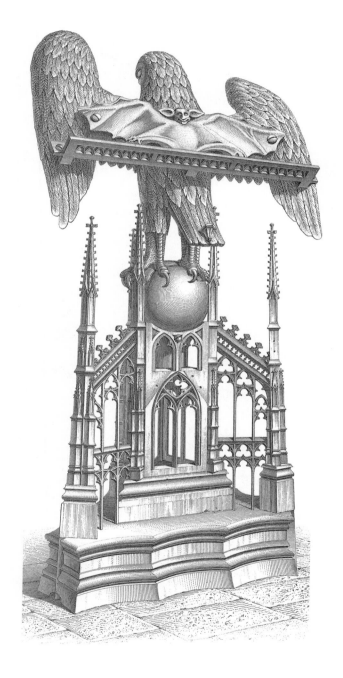

69. Lectern, Church of Notre Dame, Aix-la-Chapelle (Aachen), Germany

70. Wooden Stalls, Church of Ratzburg, Germany

71. Details of Wooden Stalls, Church of Ratzburg, Germany

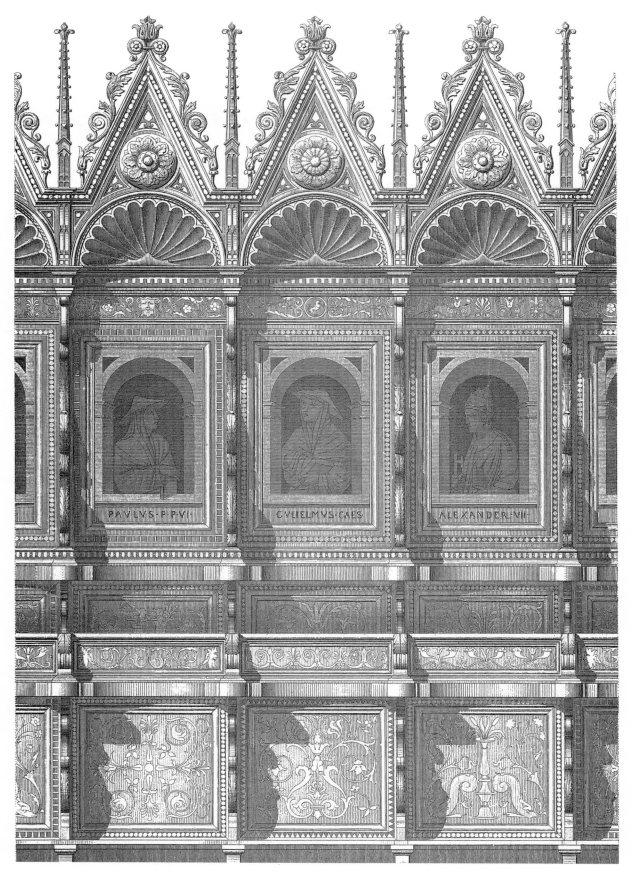

72. Stalls, Church of St. Francis, Assisi, Italy

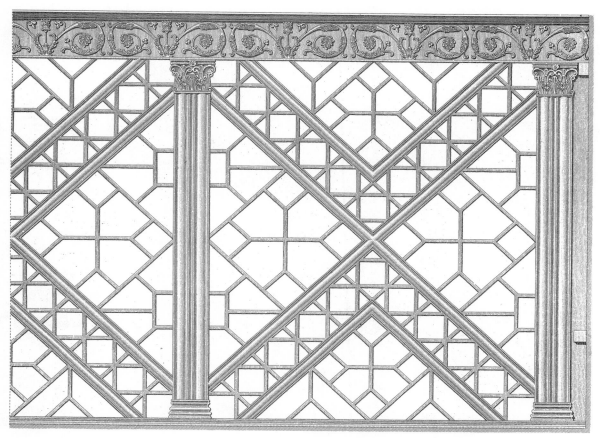

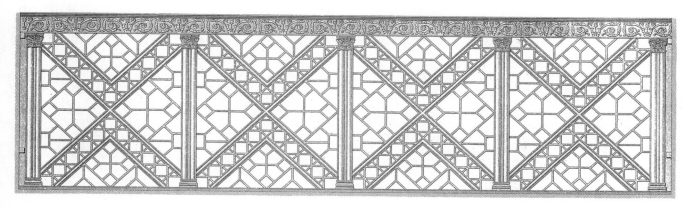

73. Bronze Enclosure, Church of Notre Dame, Aix-la-Chapelle (Aachen), Germany

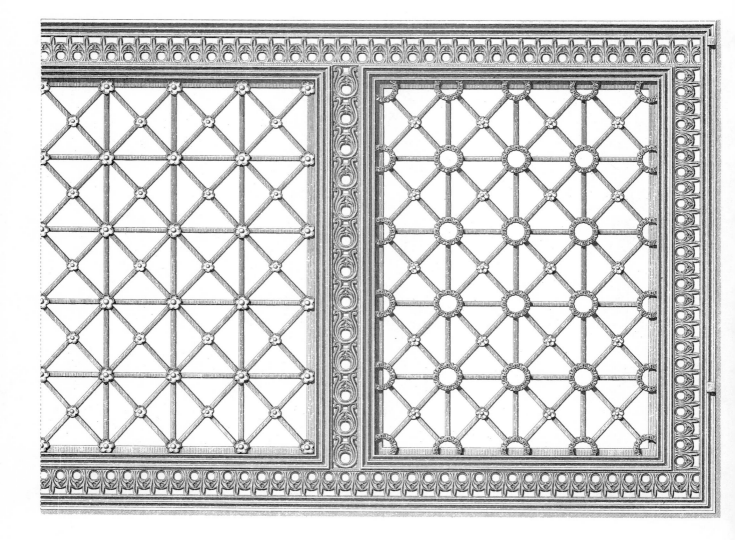

74. Bronze Enclosure, Church of Notre Dame, Aix-la-Chapelle (Aachen), Germany

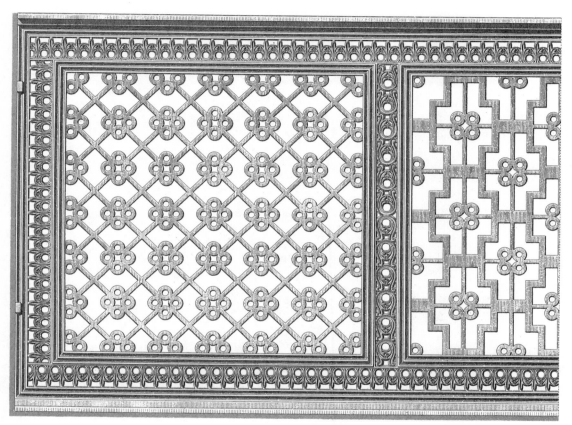
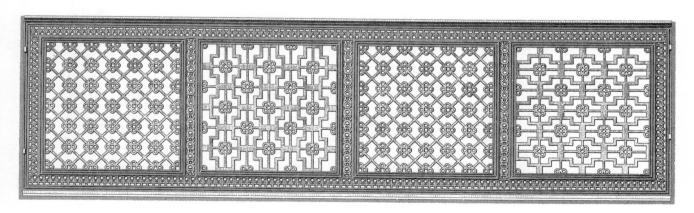

75. Bronze Enclosure, Church of Notre Dame, Aix-la-Chapelle (Aachen), Germany

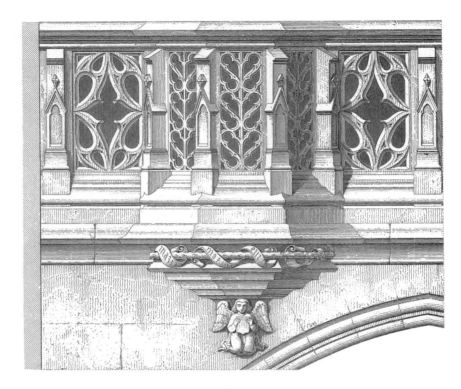

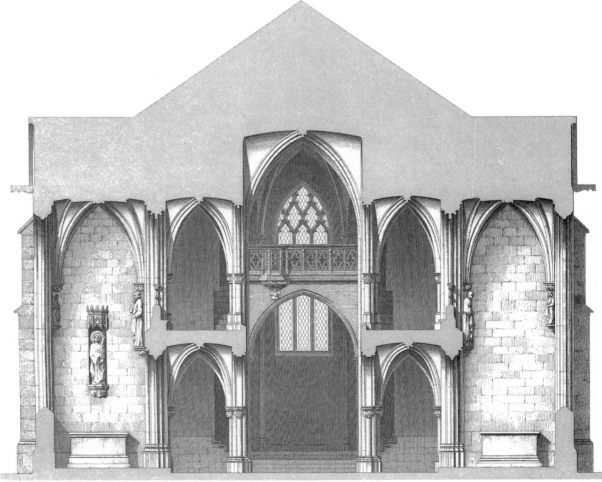

76. Rood Loft, Church of Flavigny, France

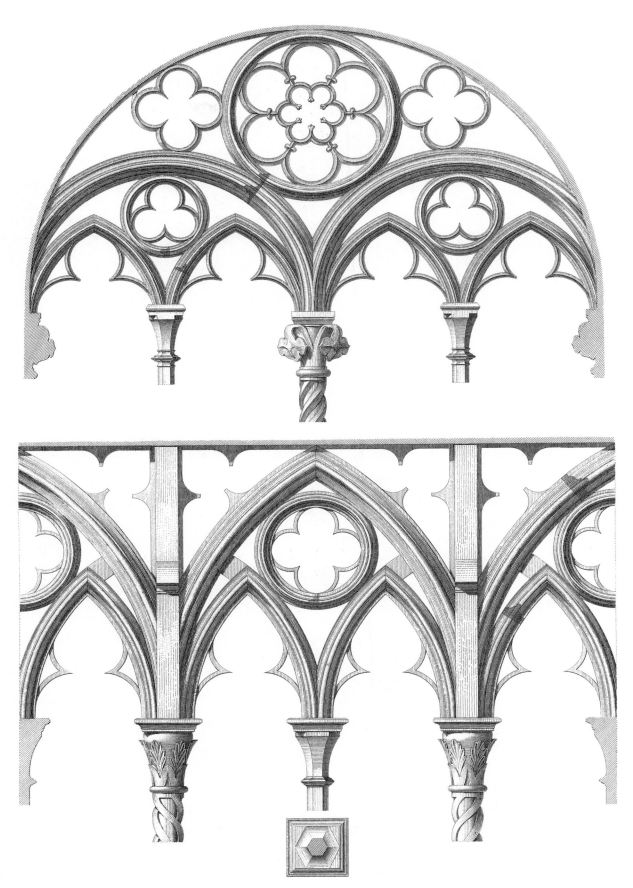

77. Details, Iron Enclosure, Sacristy, Church of St. Croix, Florence, Italy

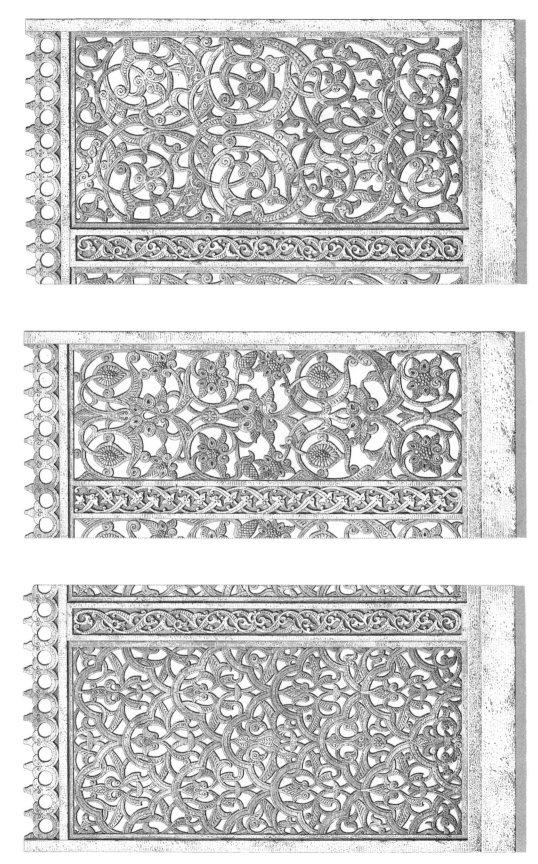

78. Stone Enclosures, Mosque of El Gaouly, Cairo, Egypt

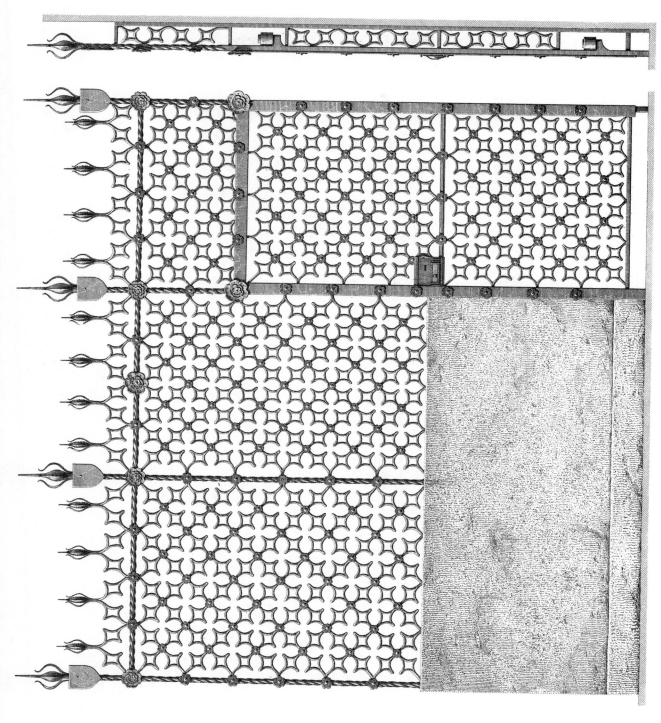

79. Iron Enclosure, Church of Langeac, France

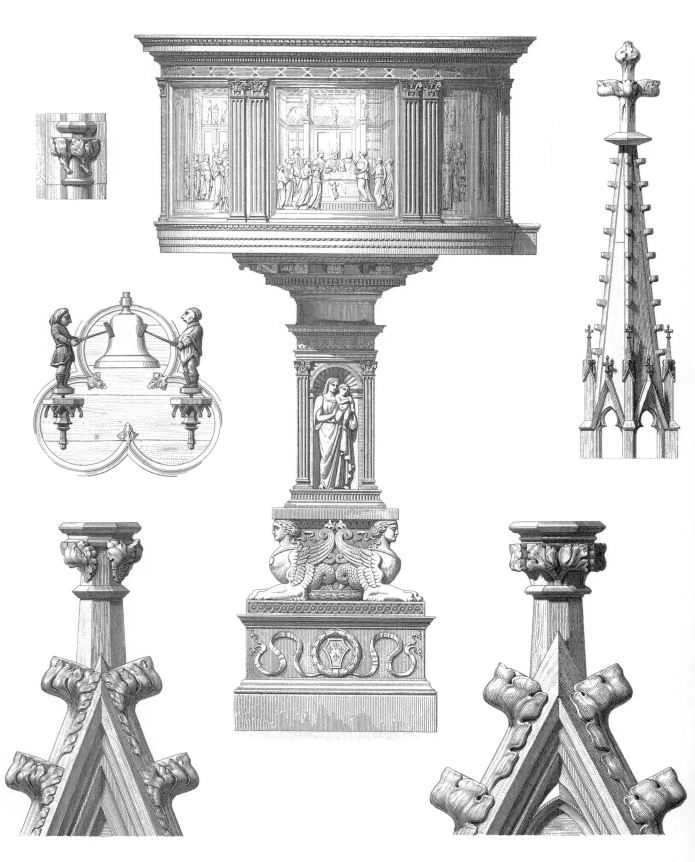

80. Pulpit, Cathedral Church, Pistoia, Italy; Clock Tower, Cathedral Church, Reims, France

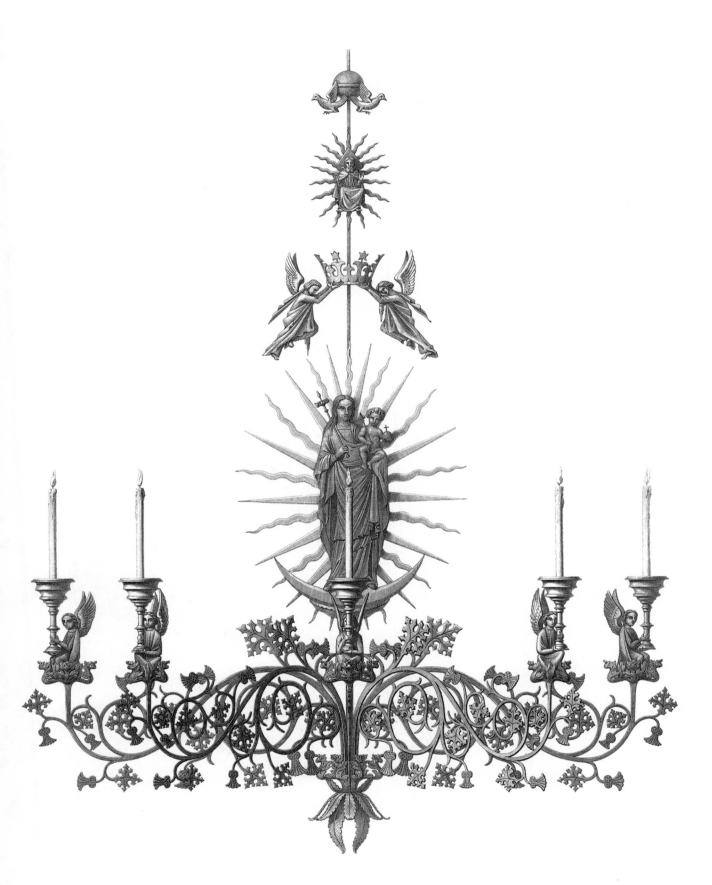

81. Suspended Virgin, Church of Kempen, Germany

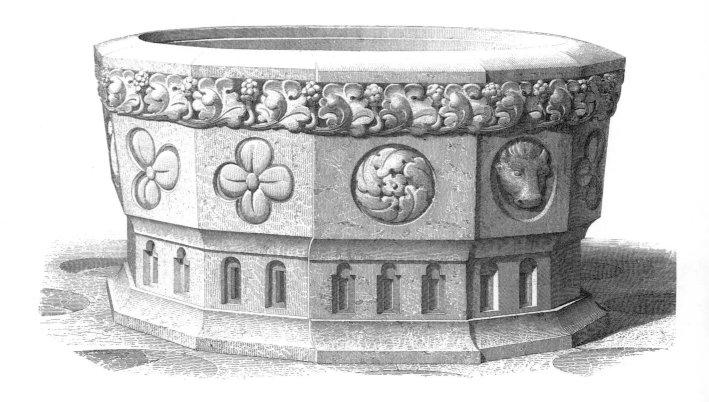

82. Baptismal Font, Church of Limay, France

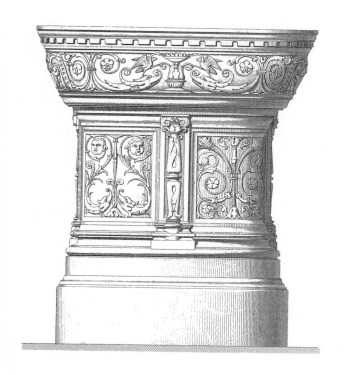
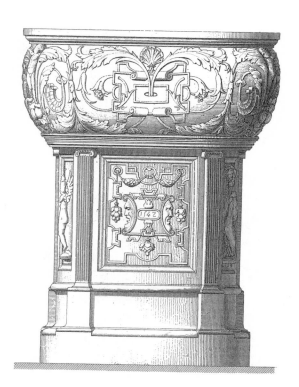
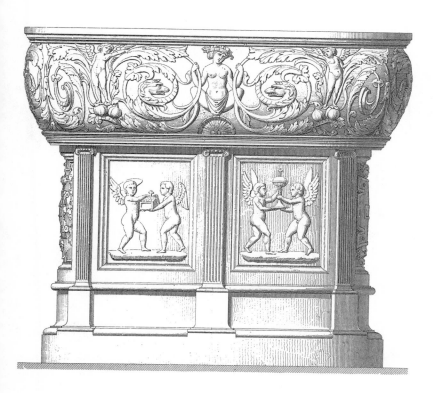
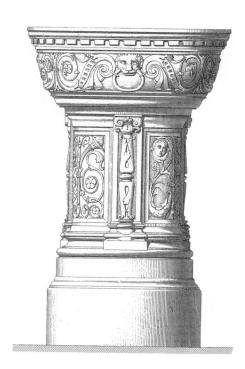

83. Baptismal Fonts at Paris and Bercy, France

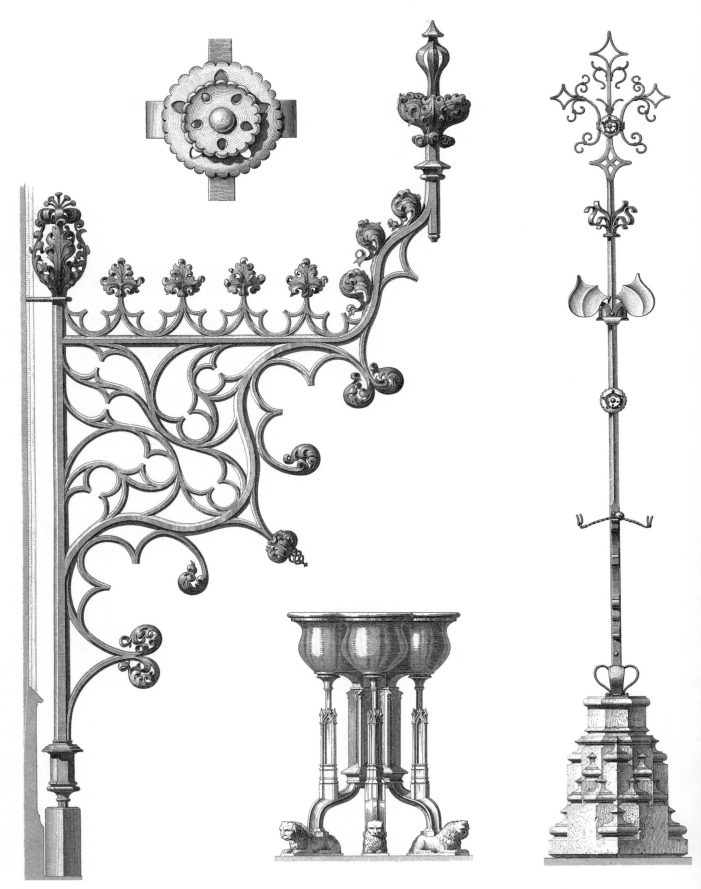

84. Baptismal Fonts, Church of St. Pierre, Louvain, Belgium; Funerary Lighting
Utensils, Cologne and Neuss, Germany

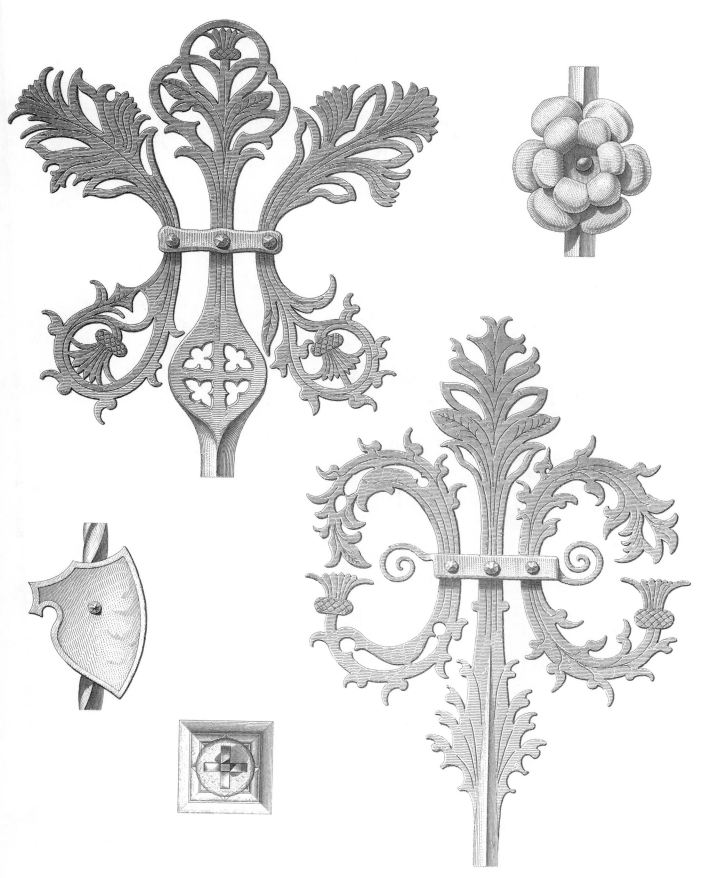

85. Funerary Lighting Utensils, Church of St. Géréon, Cologne, Germany

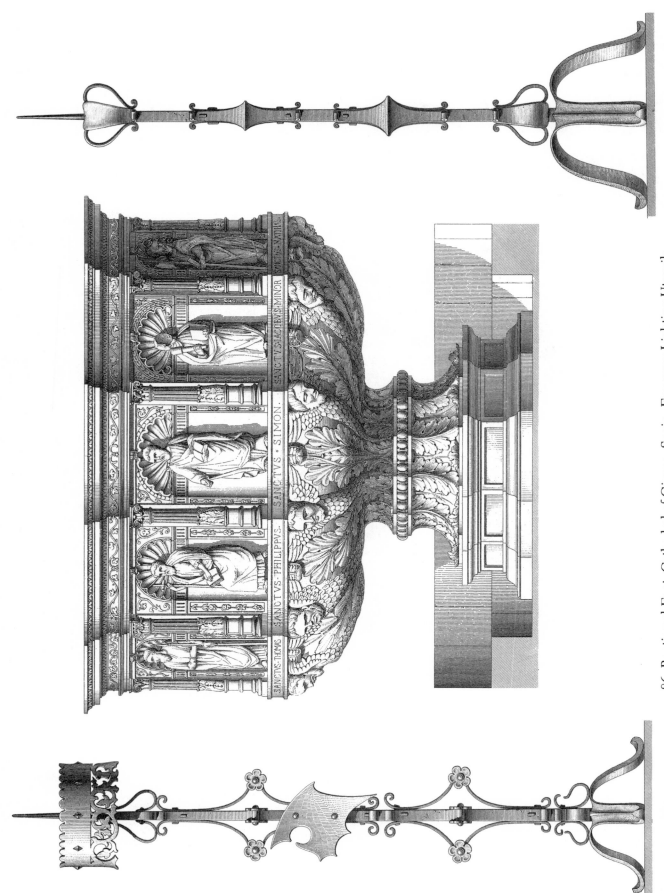

86. Baptismal Font, Cathedral of Girona, Spain; Funerary Lighting Utensils at Cologne and Neuss, Germany

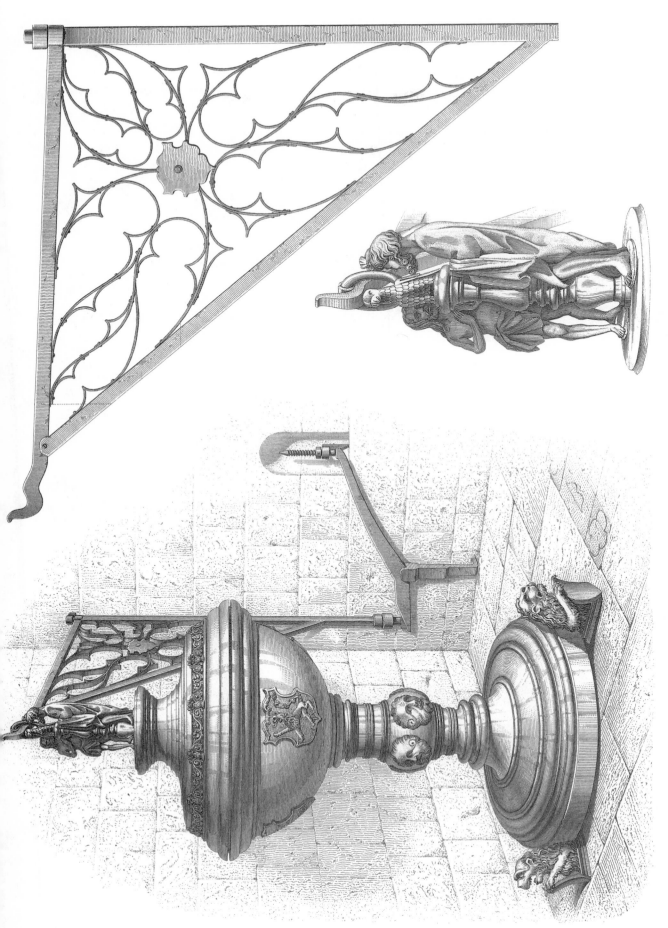

87. Baptismal Font, Church of Ste. Colombe, Cologne, Germany

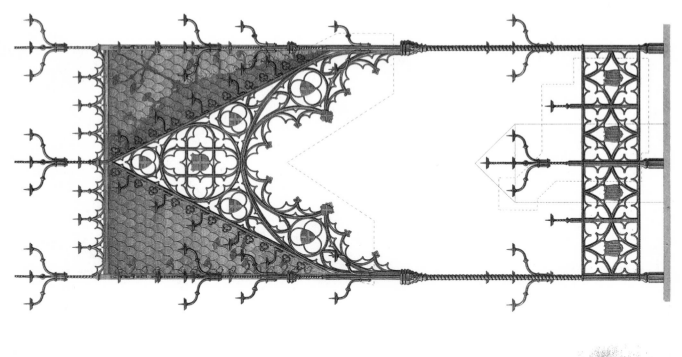

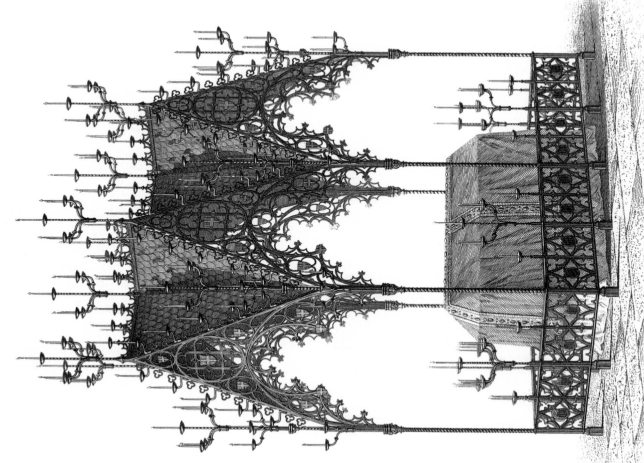

88 Funerary Chapel, Nonnburg, near Salzburg, Austria

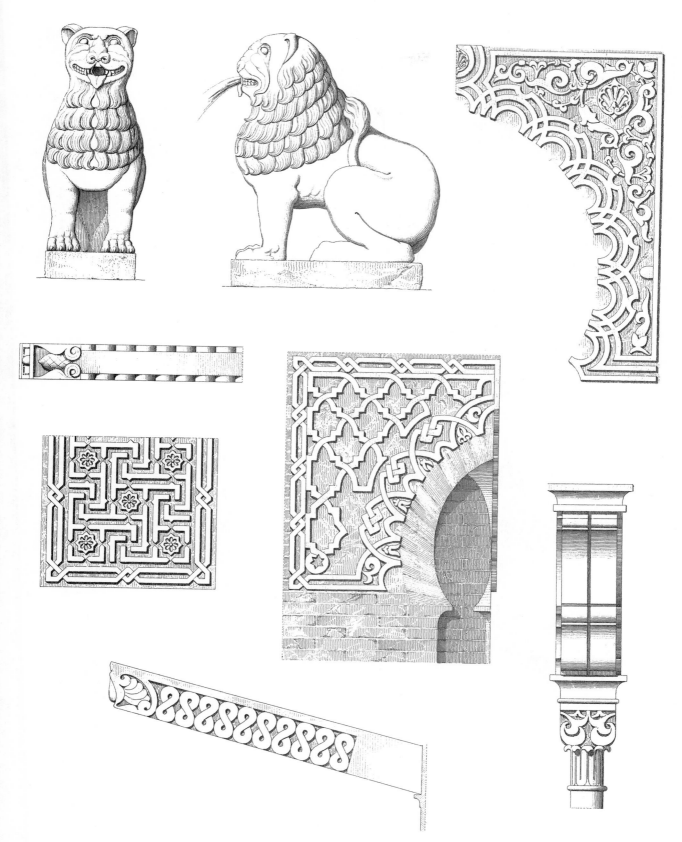

89. Details, Arab Hospital, Grenada, Spain